We are as numb
in our new electric world

as the NATIVE involved

in our literate and

MECHANICAL CULTURE.

Youth instinctively understands the present environment - the electric drama. It lives mythically and in depth.

The mosaic form
demands participation
and involvement in
depth, of the whole
being, as does the
sense of touch.

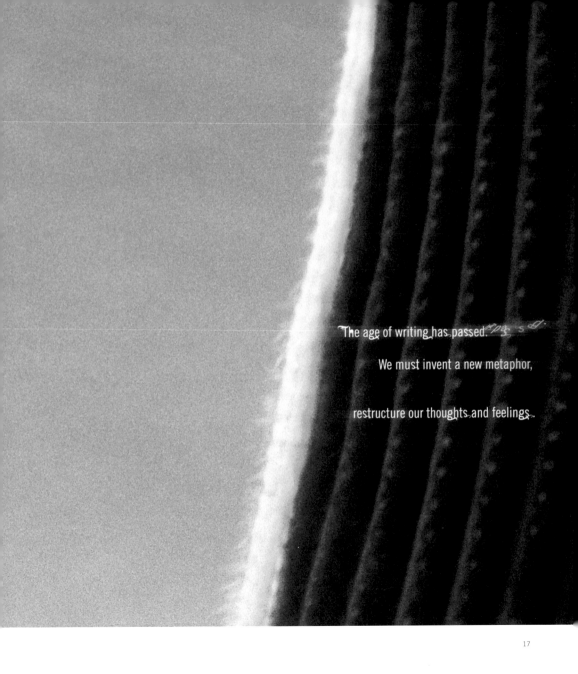

The age of writing has passed.

We must invent a new metaphor,

restructure our thoughts and feelings,

The new media

ARE NOT bridges between man and
nature

- they are nature.

WHILE PEOPLE ARE ENGAGED IN creat

wo

g a totally different

D, they always

form VIVID IMAGES of the preceding world.

Societies have always been shaped more by the nature of the media by which humans communicate

than by the

content of the com-
munication.

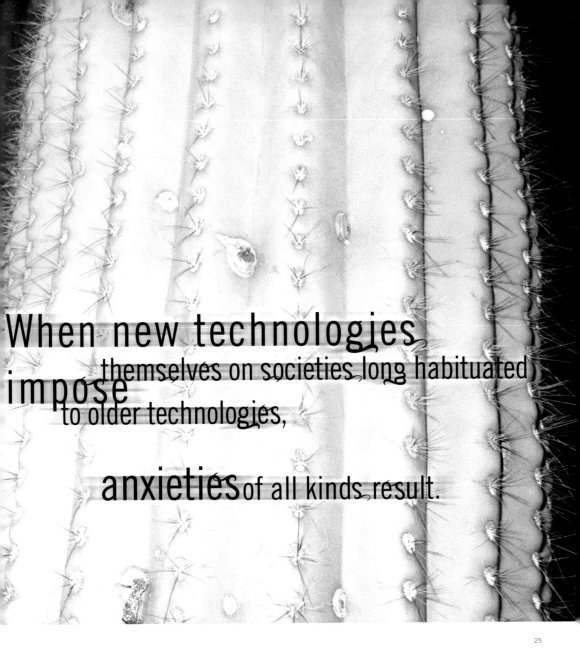

When new technologies themselves on societies long habituated
impose to older technologies,

anxieties of all kinds result.

We have become like the most primitive

Palaeolithic man, once more global wanderers,

but information gatherers rather than food gath
erers. From now on the source of food,

wealth and life itself will be

information.

oday we live

nvested

with an electric infor-
nation environment
hat is quite as imper-
eptible to us as water is to a
sh.

The role of the artist is to create an Anti-environment as a

means of perception and adjustment

Without
an anti⁓
environ⁓
ment,

all environments are invisible.

Marshall
McLuhan

T H E

BOOK OF
Probes

daviDCarson

GINGKO PRESS

COMPILED AND EDITED BY

ERIC MCLUHAN
WILLIAM KUHNS
MO COHEN

GENERAL
EDITORS

Marshall McLuhan Project
W. Terrence Gordon
Eric McLuhan
Philip B. Meggs

402

The space of early Greek cosmology was structured by

Logos

- resonant utterance or word.

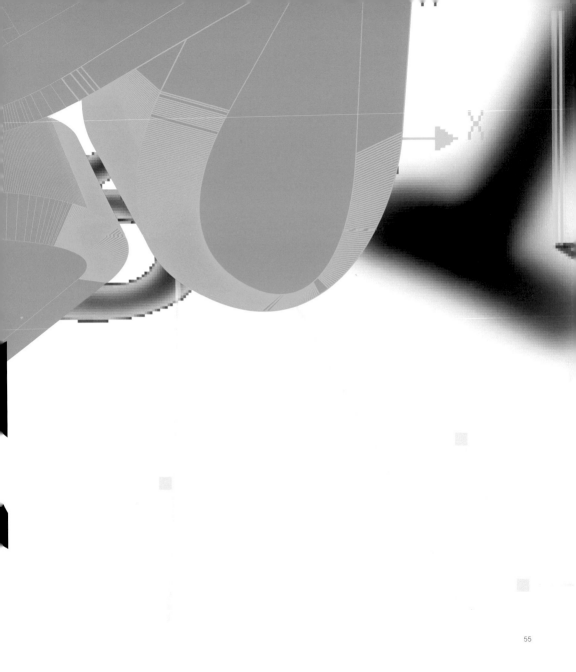

Until writing was invented, we lived in acoustic space, where the Eskimo now lives: boundless, directionless, horizonless, the dark of the mind, the world of emotion, primordial intuition, terror.

Speech is a social chart of this dark bog.

Literate man, civi-
lized man,
tends to restrict and to
separate functions,
whereas tribal man has

freely extended the

form of his body

to include the universe.

For tribal man **S**pace was the uncontrollable mystery. For technological man it is TIME that occupies the same role.

Any new technology is an evolutionary and biological mutation opening doors of perception and new spheres of action to mankind.

Literacy, the visual technology, dissolved the tribal magic by means of its stress on fragmentation and specialization and created the **indi**

vidual .

The unique innovation
of the phonetic alphabet
released the Greeks from the
universal acoustic spill of triba

ocieties.

Literacy, in translating
man out of the closed
world of tribal depth and
resonance, gave man an
eye for an ear and
ushered him into a visual
open world of specialized
and divided
consciousness.

There are no connections in resonant Space.

There are only interfaces and metamorphose s.

Speech structures the abyss of mental and acoustic space, shrouding the race; it is a cosmic

invisible architecture of the

human dark

Native societies did not think of themselves as being in the world as occupants but considered that their rituals

created the world and keep it operational.

Writing turned a spotlight on the high, dim Sierras of speech; writing was the visualization of acoustic space.

It lit up the dark.

Prolonged mimesis of the alphabet and its fragmenting properties

produced a new dominant mode of perception and then of culture.

Today, with all our technology, and because
of it,

we stand once more in the magical acousti-
cal sphere

of pre-literate man ■

The ways of thinking implanted by electronic culture are very different from those fostered by print culture. Since the Renaissance most methods and procedures have strongly tended towards stress on the visual organization and application of knowledge.

The tribalizing power of the new electronic media

the way in which they return us to the unified fields of the old oral cultures, to tribal cohesion and pre-individualist patterns of thought

is little understood.

Tribalism is the sense of the deep bond of family, the closed society as the norm of community

Today man has no physical body. He is translated into information, or an image.
mation, or an image.

Mass man is a phenomeno

f electric speed, not of physical quantity.

When we put

our central

nervous system

outside us we

returned to the primal nomadic state.

THE ELECTRONIC AGE IS A

AND E FFECTS BECOME

ABLE, AS IN MUSIC ST

WORLD IN WHICH CAUSES

ALMOST INTERCHANGE—

UCTURES.

Unlike previous environmental
changes, the electric media
constitute a total and
near-instantaneous
transformation of culture,
values and attitudes.

People in new environments always produce the new perceptual modality without any difficulty or awareness of change. It is later that the psychic and social realignments baffle societies.

When you move
and learn a new
new subject, it

nto a new area, a new territory
anguage, the language is not a
an environment, it is TOTAL.

*The existentialist trauma had a physica
in the first electric extension*

...asis
of our nervous system.

*Today we experience,
in reverse, what pre-literate*

...an faced with the advent of writing.

When the evolutionary process shifts from biology to software technology the body becomes the old hardware environment. the

human body is now a probe, a laboratory for experiments.

Today, computers hold out the promise of a means of instant translation of any code or language into any other code or language.

At the very high speed of living, everybody needs a new career and a new job and a totally new personality every ten years.

ADVERTISING

Q: Do you feel a need to be distinctive and mass-produced?

Q: Are you in the groove?

That is, are you moving
in ever-diminishing circles?

Q: How often do you change your mind, your politics, your clothes?

The metropolis today is a classroom, the ads are its teachers.The

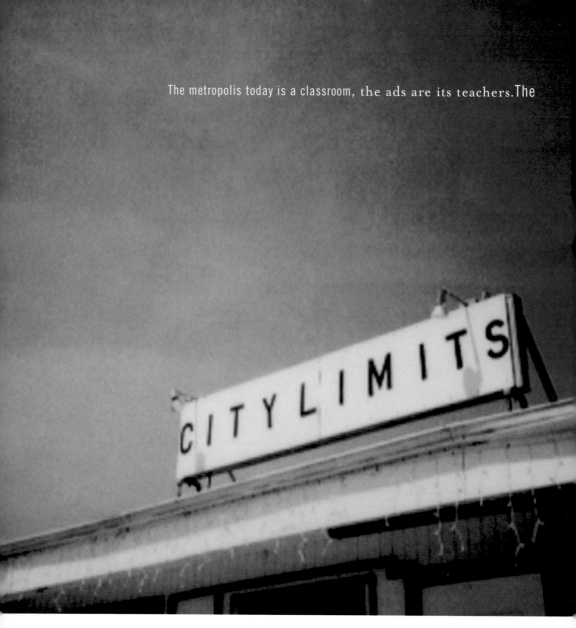

traditional classroom is AN OBSOLETE DETENTION HOME, a feudal dungeon.

Advertising is the art form of the 20th century.

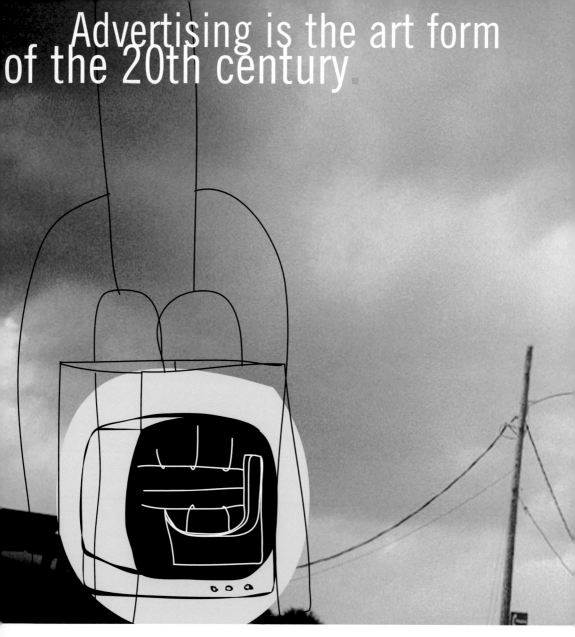

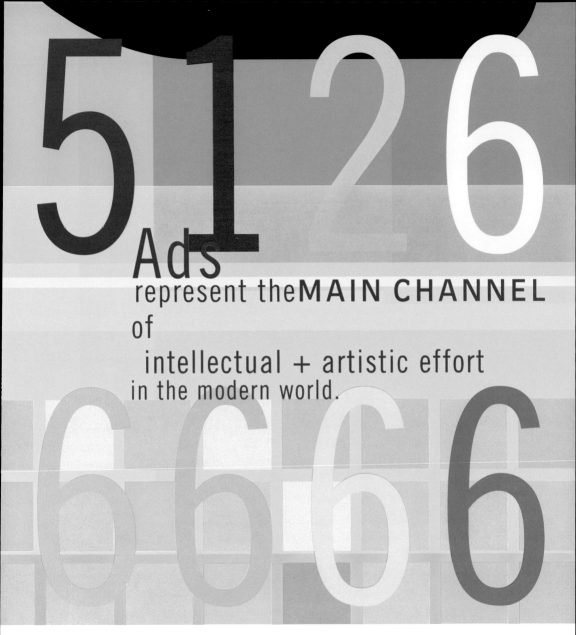

Ads represent the**MAIN CHANNEL** of intellectual + artistic effort in the modern world.

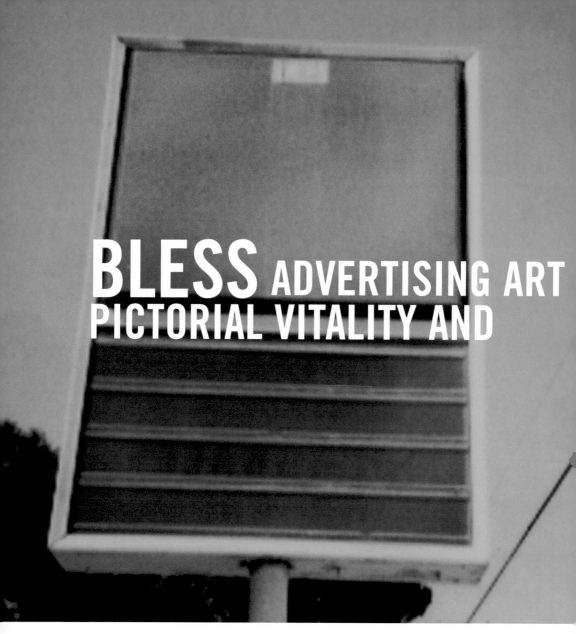

BLESS ADVERTISING ART PICTORIAL VITALITY AND

FOR ITS
VERBAL CREATIVITY.

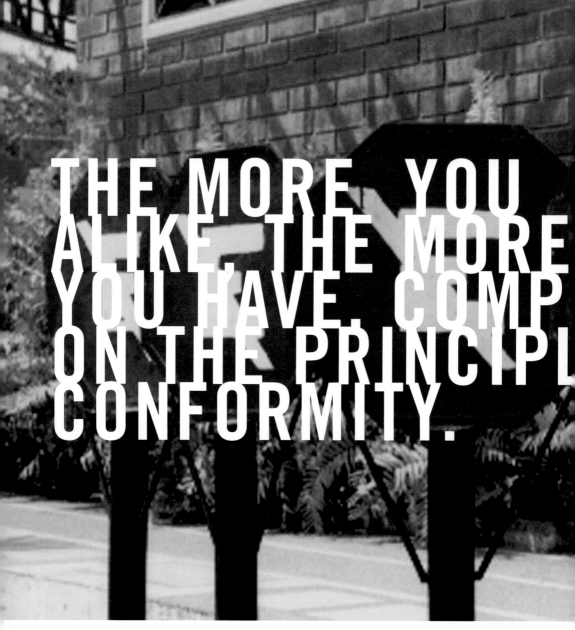

THE MORE YOU ALIKE, THE MORE YOU HAVE, COMP ON THE PRINCIPL CONFORMITY.

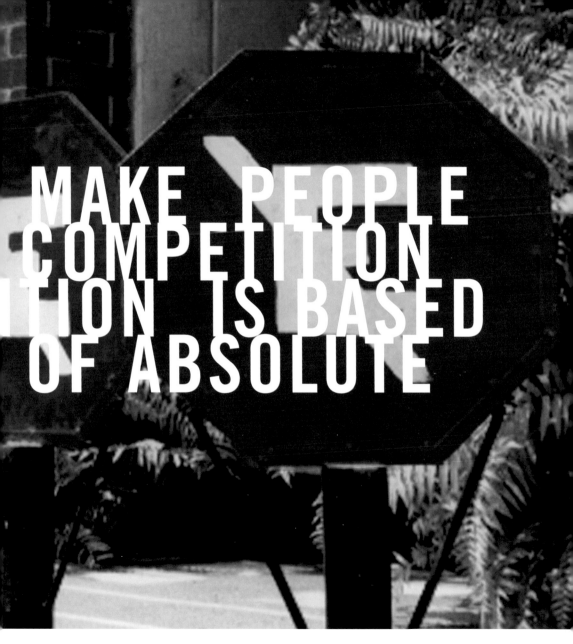

MAKE PEOPLE
COMPETITION
ITION IS BASED
OF ABSOLUTE

Why is America the land of the overrated child and the underrated adult?

Q: How can children grow up in a world in which adults idolize **youthfulness?**

Q: What happens when the **ad makers** take over all the popular myths and poetry?

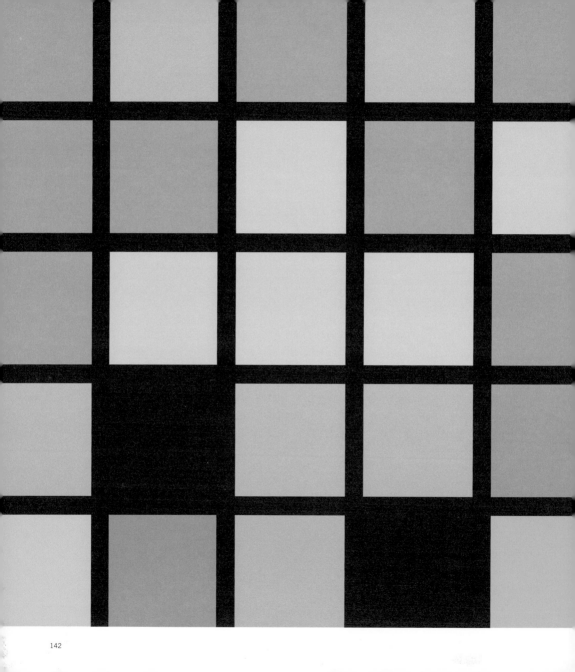

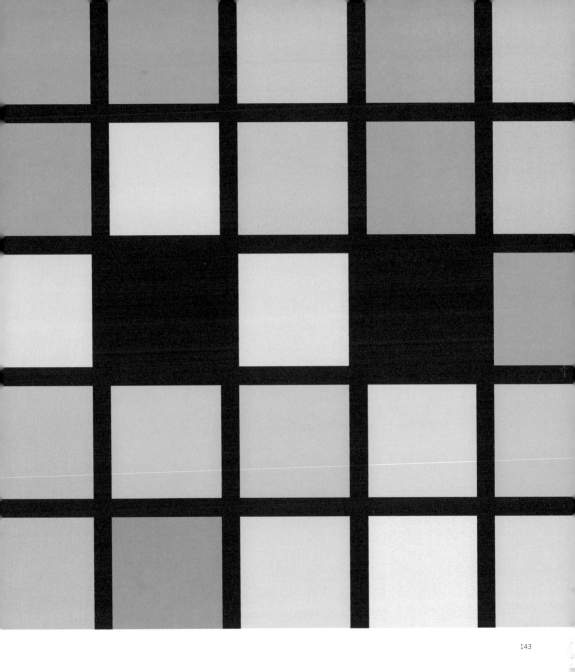

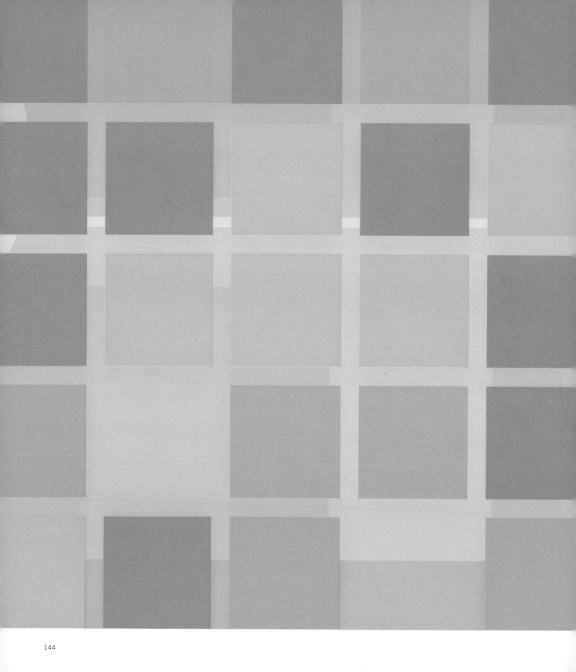

All advertising
advertises
advertising —
no ad has its
meaning

alone.

School is the advertising agency which makes you believe you need the society as it is.

he only cool PR is provided by one's enemies. They toil incessantly and for free.

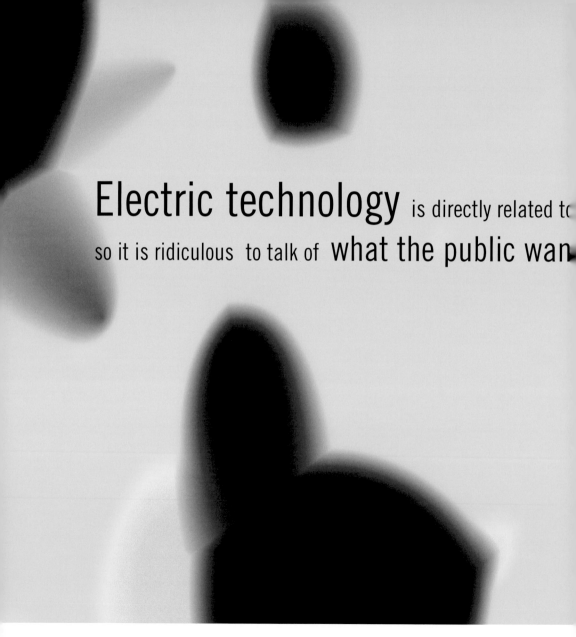

Electric technology is directly related to so it is ridiculous to talk of what the public wan

ur central nervous system

played over its own

nerveS

Technologies — MEDIA — The Extensions of Man

Media are means of extending and enlarging our organic sense lives into our environment.

When technology extends one of our senses, a new translation of culture occurs as swiftly as the new technology is interiorized.

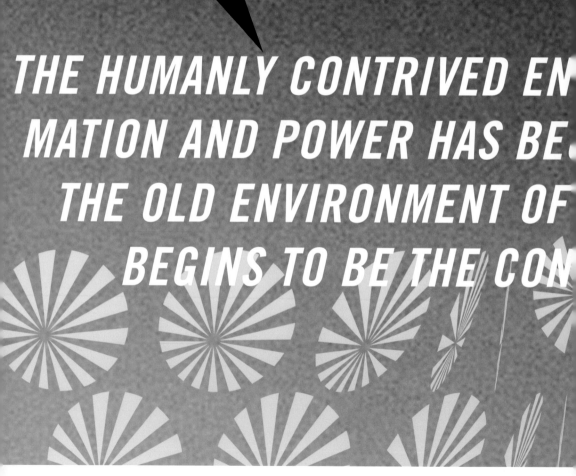

*THE HUMANLY CONTRIVED EN
MATION AND POWER HAS BE
THE OLD ENVIRONMENT OF
BEGINS TO BE THE CON*

ONMENT OF ELECTRIC INFOR-
TO TAKE PRECEDENCE OVER
URE. NATURE, AS IT WERE,
T OF OUR TECHNOLOGY.

Nature is an item contained in a man-mad

nvironment of satellites and information.

EACH NEW TECHNOLOGY IS A

REPROGRAMMING OF SENSORY LIFE.

Language

does for intelligence

what the wheel does for the feet and the body.

It enables them to move from

thing to thing

with greater ease and speed

and less involvement.

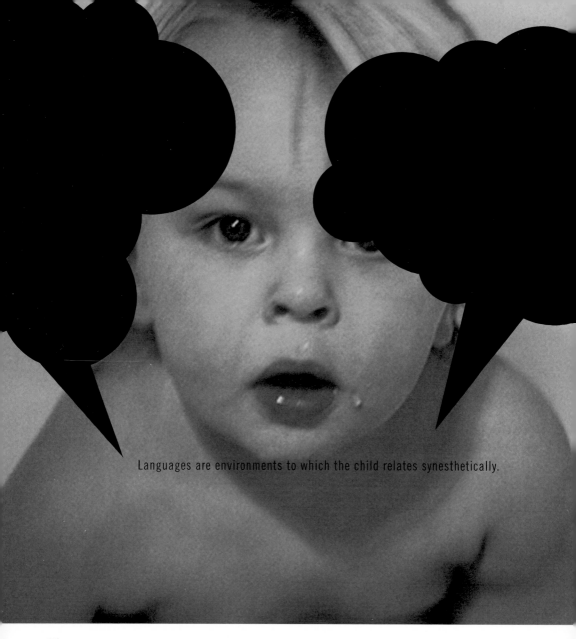

Languages are environments to which the child relates synesthetically.

After childhood, the senses specialize via the channels of dominant technologies and social weaponries.

Every mode of technol- ogy

is a reflex of our most

intimate psychological experience.

THE MOST **HUMANO**
THING ABOUT US IS

OUR TECHNOLOGY .

Media Ecology

All media exist to invest our lives with artificia
perception and arbitrary values.

The media have substit
the older world.



d themselves for

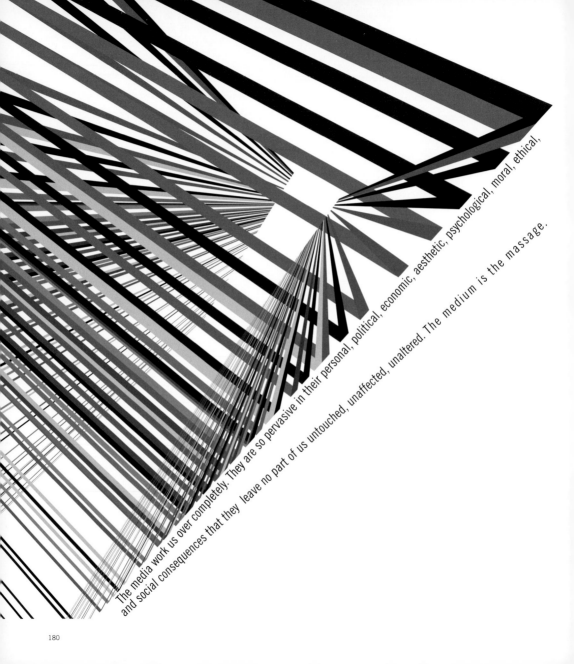

The media work us over completely. They are so pervasive in their personal, political, economic, aesthetic, psychological, moral, ethical, and social consequences that they leave no part of us untouched, unaffected, unaltered. The medium is the massage.

The bias of each medium of communication is far more distorting than the deliberate lie.

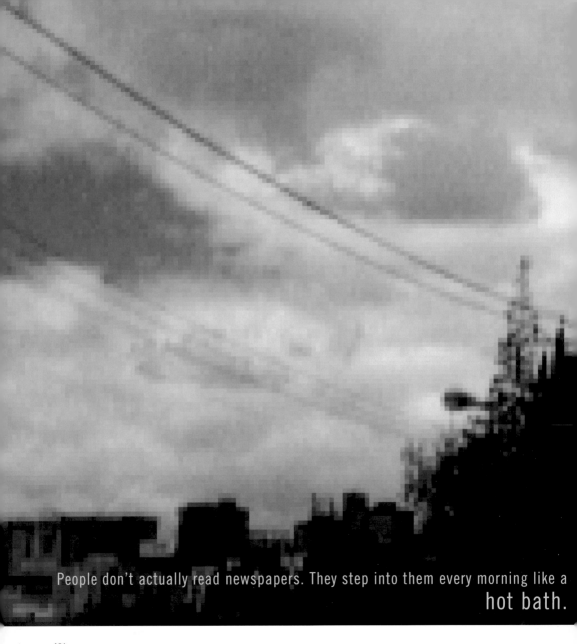

People don't actually read newspapers. They step into them every morning like a
hot bath.

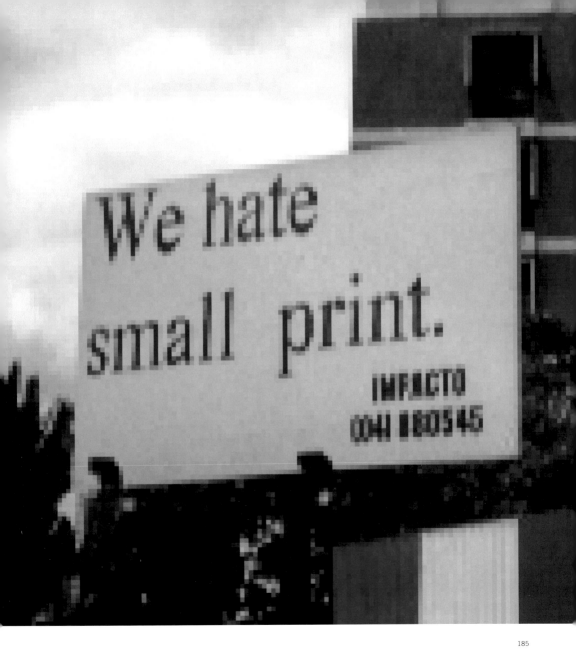

The TV camera has no shutter. It does not deal with aspects or facets of objects in high resolution. It is a means of direct pick-up by the electrical **groping** over surfaces.

RADIO COMES TO US OSTENSIBLY WITH PERSON TO PERSON DIRECTNESS THAT IS PRIVATE AND INTIMATE, WHILE IN MORE URGENT FACT, IT IS REALLY A SUB-LIMINAL ECHO CHAMBER OF MAGIC POWER TO TOUCH REMOTE AND FORGOTTEN CHORDS.

With TV, came the icon, the inclusive image, the inclusive political pos-ture or stance.

New media are new archetypes, at first disguise

as degradations of older media.

In television, images are projected at you.
YOU ARE THE SCREEN. The images wrap
around you. You are the

vanishing point

The discarnate TV user lives in a world between fantasy and dream, and i

pically **hypnotic** state, which is the ultimate form and level of participation.

One of the many effects of television on radio has been to shift radio from an entertainment medium into a kind of nervous information system.

The TV generation is postliterate and retribalized. It seeks by violence to scrub the old private image and to merge in a new tribal identity, like any corporate executive.

The subliminal depths **OF RADIO**

are charged with the resonating echoes of ribal horns and antique drums. This is inherent in the very nature of this

medium, with its power to turn the psyche and society into a single echo chamber.

Only puny secrets need protection. BIG SECRETS are protected by public incredulity. You can actually dissipate a situation by giving it maximal coverage.
As to alarming people, that's done by rumors, not by coverage.

"The stock market was created b
and its PANICS ARE ENGIN
stories in the press.

he telegraph and the telephone,
RED by carefully orchestrated

The unformu
every quarte
ALL WAR I

d message of an assembly of news items from f the globe is that the world today is one city.

CIVIL WAR. **,,**

The press is a GROUP CONFESSIONAL form that provides communal participation.

The book is a **private confessional** form that provides a "point of view."

The Laws of Media

16 11

In an age of multiple and massive innovations,

15

obsolescence becomes the major obsession.

EVERY INNOVATION SCRAPS ITS IMMEDIATE PREDECESSOR AND
RETRIEVES STILL OLDER FIGURES — IT CAUSES FLOODS OF ANTIQUES
OR NOSTALGIC ART FORMS AND STIMULATES THE SEARCH FOR
"MUSEUM PIECES."

Obsolescence is the moment of
superabundance.

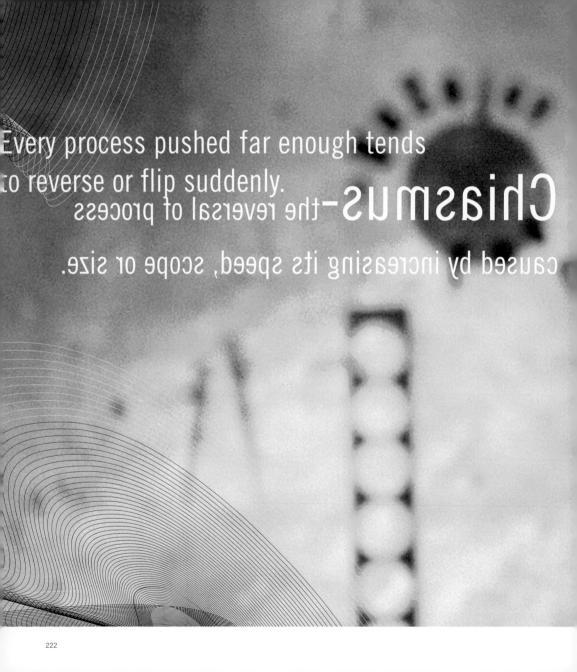

Every process pushed far enough tends
to reverse or flip suddenly.
Chiasmus—the reversal of process
caused by increasing its speed, scope or size.

All meaning alters with acceleration, because all patterns

of personal and political inter dependence change with any

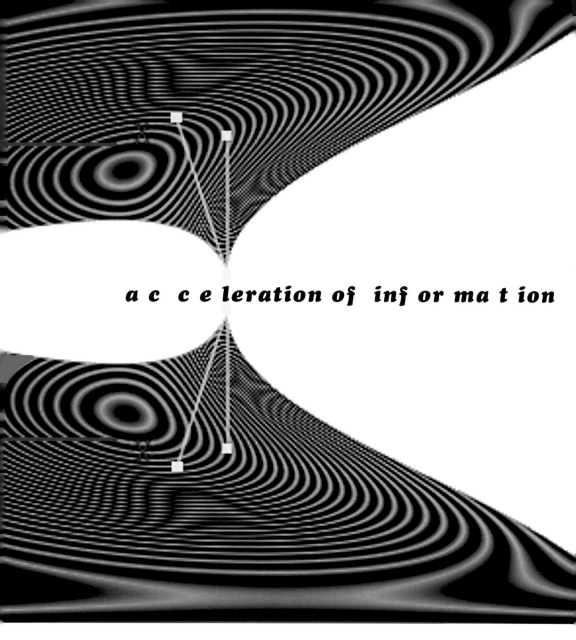

a c c e leration of inf or ma t ion

All of man's artefacts, whether hardware or software, whether bull-
dozers or laws of chemistry, are alike linguistic in structure and

intent.

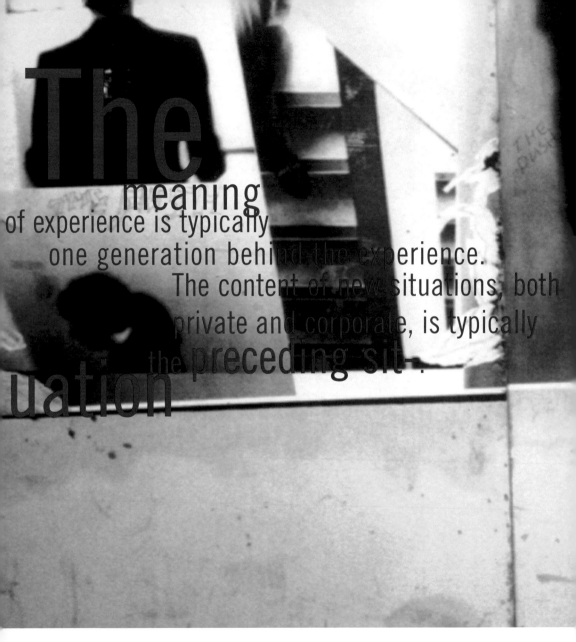

The meaning of experience is typically one generation behind the experience. The content of new situations, both private and corporate, is typically the preceding sit-uation.

It is th

It is the

that sh

trols th

that shapes

form or

controls the

human associa

and form of

human associati

es and con-
m
cale and

le

and action.

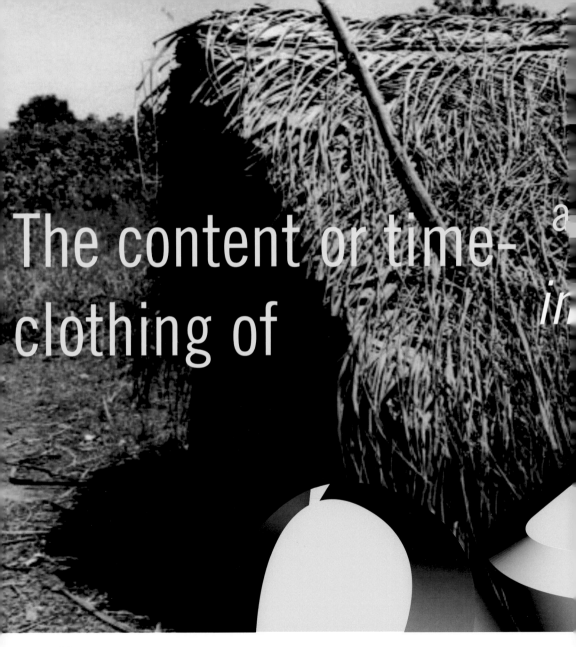

The content or time-
clothing of

a

in

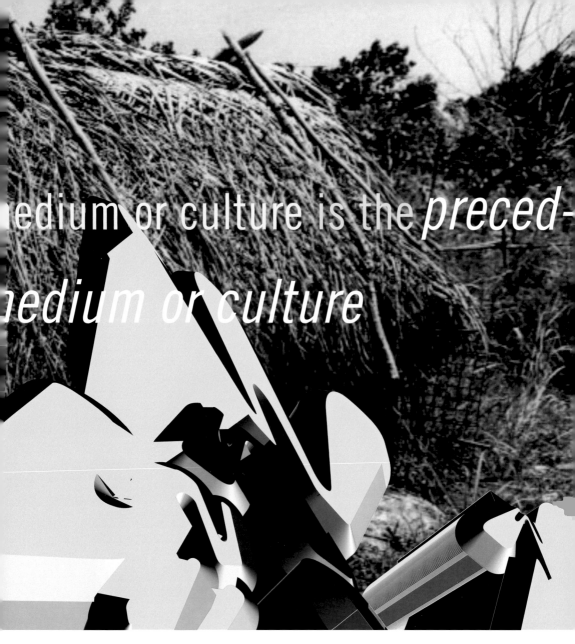

edium or culture is the *preced-*

edium or culture

The audience, as *ground*, shapes and

controls the work of art.

All words
at every level
of prose and poetry
and all devices of language and speech derive
their meaning from figure / ground relation.

All words, in every language, are metaphors.

LOGIC

is figure without a ground.

sense

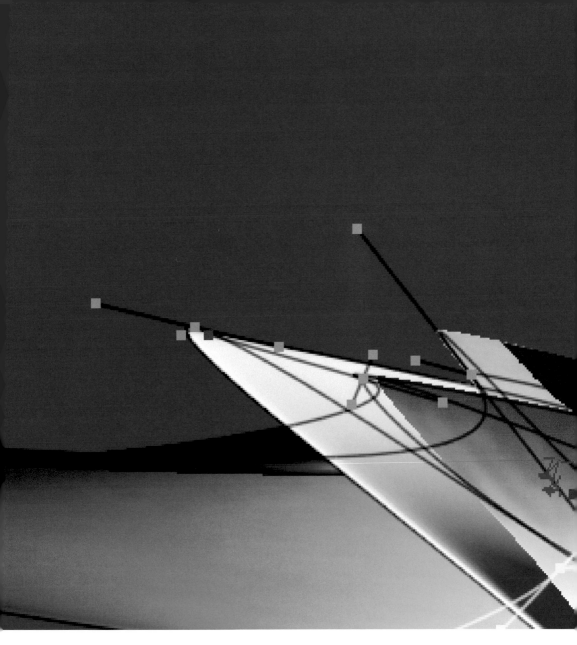

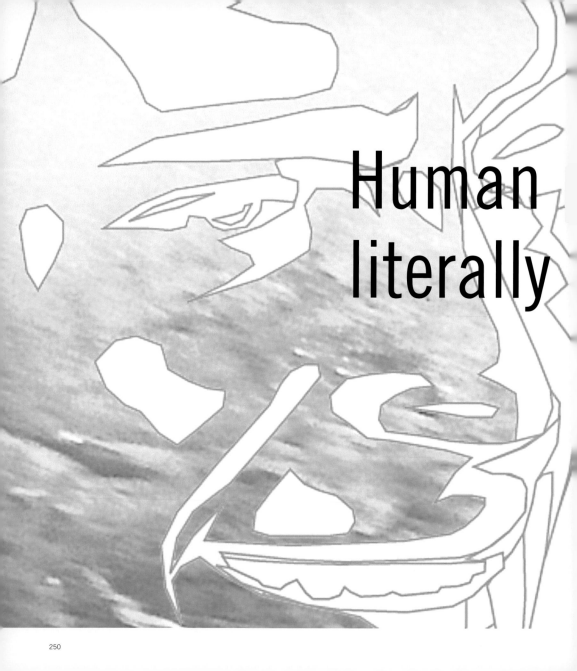

Human
literally

erception is
ncarnation.

LANGUAGE
INCLUDES
SENSES IM
AT

ALONE
ALL THE
INTERPLAY
ALL TIMES

Color is not so much a visual as a tactile medium.

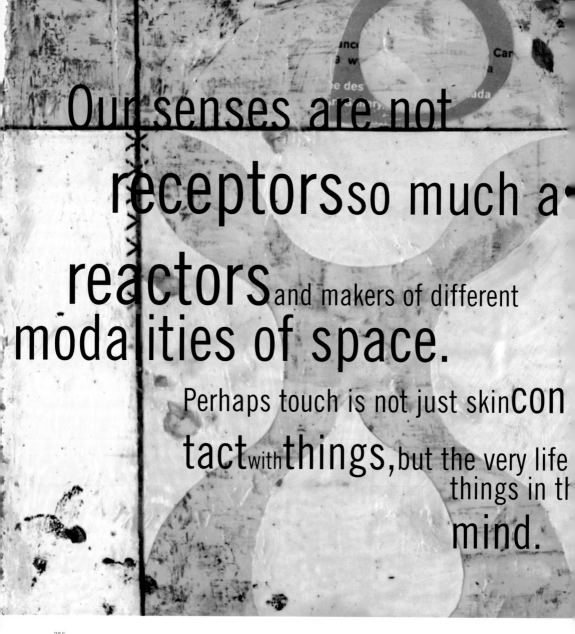

Our senses are not receptors so much a·
reactors and makers of different
modalities of space.
Perhaps touch is not just skin con
tact with things, but the very life
things in th
mind.

Chinese script is not visual but iconic and tactile. It does not disturb the tribal bonds.

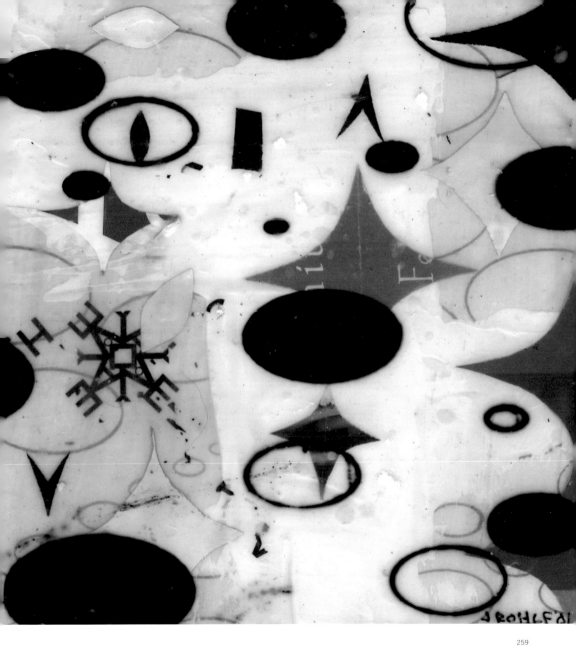

There is no connection between the elements in an electric world, which is equivalent to being sur- rounded by the human unconscious

The pre-atomist multisensory void was an animate, pulsating and moving vibrant interval, neither container nor contained—acoustic space penetrated by tactility.

The greatest propaganda in the world is our MOTHER TONGUE, THAT WHAT we learn as children, and which we learn unconsciously. That shapes our

perceptions for life.

Language is a form of organized stutter.

The NEW ELECTRIC ENVIRONMENT
of simultaneous and diversified
information creates acoustic man.
He is surrounded by sound – from
behind, from the side, from above.
His environment is made up of
information in all kinds of simul-
taneous forms, and he puts on
this electric environment as we
put on our clothes, or as the fish
puts on water.

Language is a sense, like touch.

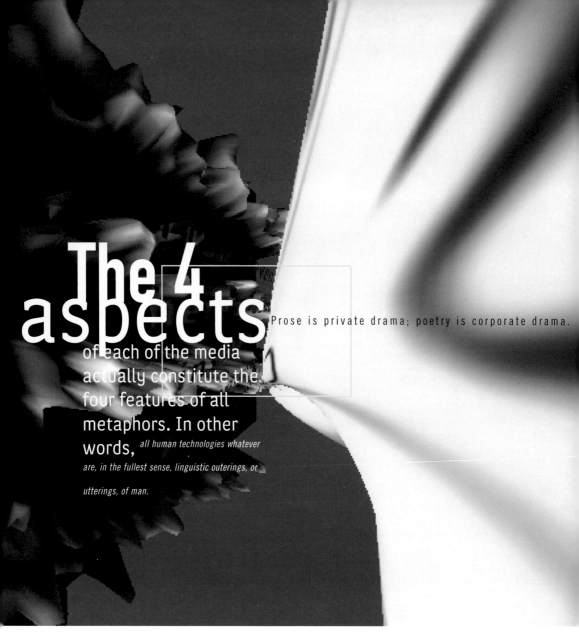

The 4
aspects

Prose is private drama; poetry is corporate drama.

of each of the media
actually constitute the
four features of all
metaphors. In other
words, *all human technologies whatever*

are, in the fullest sense, linguistic outerings, or

utterings, of man.

All media of communications are clichés serving to enlarge man's scope of action, his patterns of association and awareness.

These media create environments that numb ou

owers of attention by sheer

pervasiveness

The reader is the content of any poem or of the language he
employs, and in order to use any of these forms, he must

put them on.

Typography extended *its character to the* regulation and *fixation* of languages.

was first reflected by the printed page.

The *divorce of poetry and music*

The reduction of the tactile qualities of life and language constitute the refinement sought in the Renaissance and repudiated now in the electronic age.

Percepts of existence always lie behind concepts of nature.

285

brero de 1966, que al establec

bilación en el régimen de la ley

especto de las condiciones exig

ación. Por el contrario —y ello

ersonal que le atribuye el recu

ance de disposiciones que cons

inalidad "es compensar al pers

bancaria" y transformar "en un

oresenta una carga que amenaza

nos exigidos por las leyes jubilato

Por ello, y de conformidad

rador Fiscal se confirma la s

ue el agente debía obtener su
575, no introdujo ningún cam
para ser beneficiario de la gra
luye, obvio es decirlo, el carác
ite—, ratificó así el concepto y
yen un todo orgánico, cuya ú
por los años dedicados a la la
o grato lo que en la actualidad
cuantos ya han cumplido los tér
s" (fs. 52/53).

do dectaminado por el Señor
encia apelada en lo que pudo

The mother tongue is

propaganda

The Book of Probes

At the *speed* of light political policies and
PARTIES yield place to charismatic images

Faster

whatever creates vast wealth.

By surpassing writing, we have regained our wholeness, not on a national or cultural but cosmic plane.

Dialectic functions by converting everything it touches into figure. But metaphor is a means of *perceiving* one thing in terms of anothe.

Each of our senses makes its own space, but no sense can function in iso-

CAN THE EYE SEE

tion. Only as sight relates to touch, or kinaesthesia, or sound,

Effects are perceived, whereas causes are conceived.

Effects always precede causes in the actual developmental order.

Environments are not just containers but are processes

change the content totally.

For me any of the little ges-
tures I make are all tentative
probes. That's why I feel free to make them sound as
outrageous or extreme as possible. Until
you make it
EXTREME, the
probe is not very efficient.

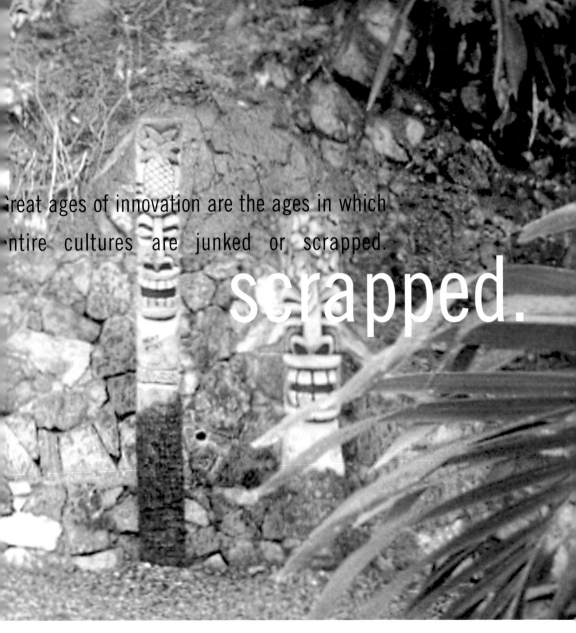

Great ages of innovation are the ages in which entire cultures are junked or scrapped.

scrapped.

I am a pattern watcher.

_If a work of
_art is to
_explore new
_environments,
_it is not to be
_regarded as a
_blueprint but
_rather as a
_form of
_action-paint-
ing.

physically
standing,
beside his
work.
That means
honesty: a
man stands by
his work. Two things: FIGURE / GROUND.

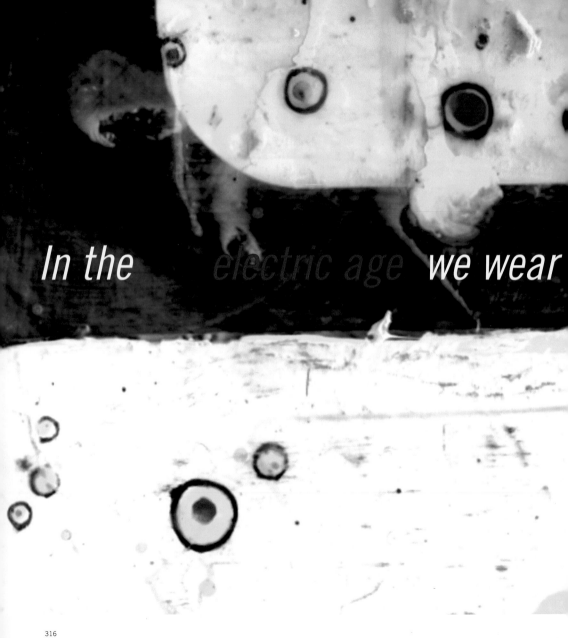

In the *electric age* we wear

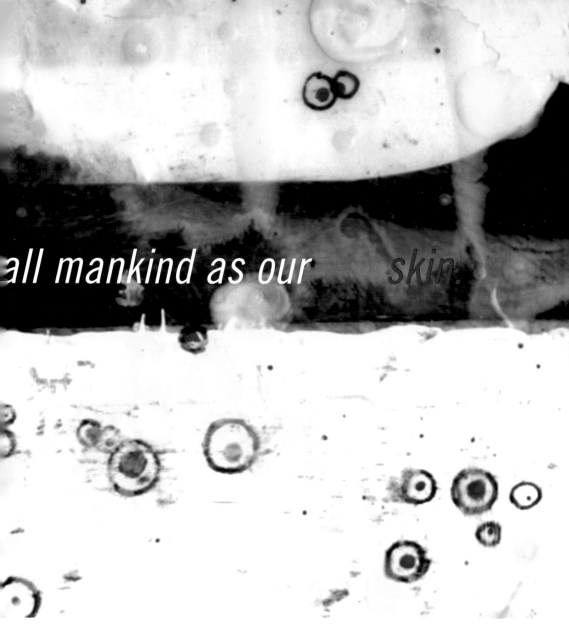

all mankind as our *skin.*

Instead of

scurrying into

a corner and
one should

wailing about
charge straight

what media are
ahead and kick
doing to us,

them in the

electrodes.

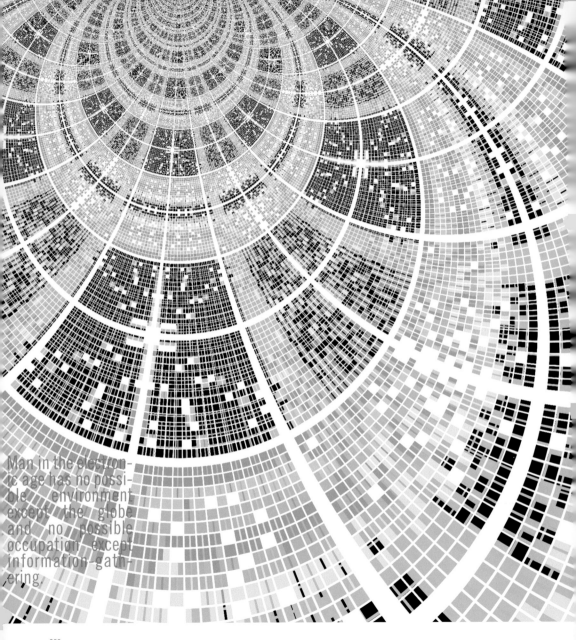

Man in the electron-
ic age has no possi-
ble environment
except the globe
and no possible
occupation except
information-gath-
ering.

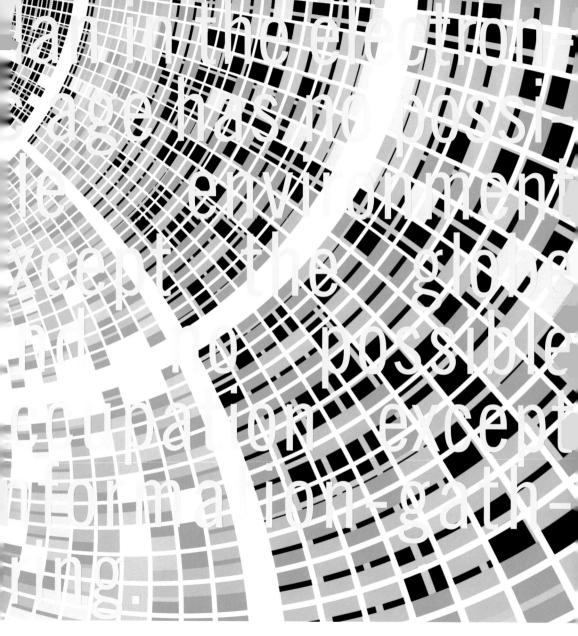

...an in the electronic age has no possible environment except the globe and no possible occupation except information-gathering.

Man**WORKS**when he is partially involved.

When he is **invTOTALlved**
he is at play
or at leisure

Money is a corporate image, depending on society for its *institutional status.*

method is vertical rather thanhorizontalso

e scenery does not change but the .

xture does

Omnipresence has become an ordinary human dimension..

PARADOX is the technique for seizing the conflicting aspects of any problem.

Paradox coalesces or telescopes various facets of a complex process in a single instant.

Phenomenology is dialectic in ear-mode..a massive and decentralized quest fc

roots, for *ground*..

Privacy invasion is now one of our biggest

knowledge industries.

Sentimentality, like pornography, is **fragmented emotion**■ a natural consequence of a **high visual gradient**❜ in any culture.

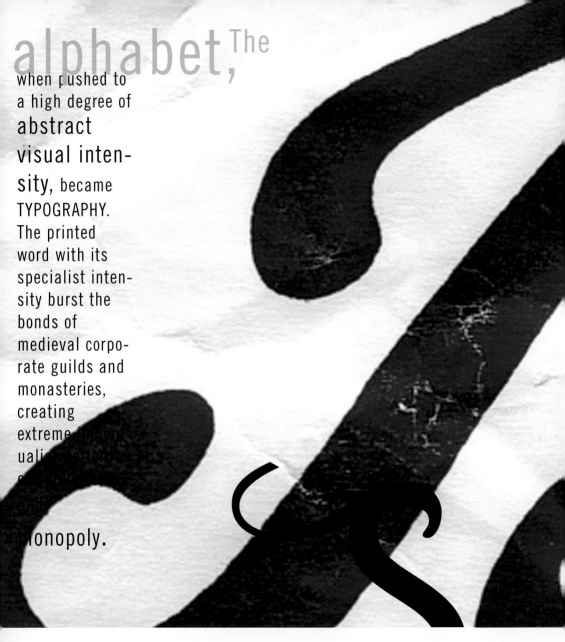

alphabet, The

when pushed to a high degree of **abstract visual intensity,** became TYPOGRAPHY. The printed word with its specialist intensity burst the bonds of medieval corporate guilds and monasteries, creating extreme individualism and nationalism and monopoly.

P MUL
E OLIVIERI

2000"

The bible belt is **oral** territory and therefore despised by the

literati.

The coverage is the war.

If there were no coverage...there'd be no war.
Yes, the newsmen and the mediamen around the world
are actually the fighters, not the soldiers anymore.

THE criminal, like the artist, is a social explorer.

" The images of mankind have become the most basic thing about them. And they're all software, and disembodied.

The invention of printing

did away with anonymity, fostering ideas of literary FAME and the habit of considering INTELLECTUAL EFFORT as private property.

e magic of the cave image
s in its *being,* not its
being seen. The symbolic
does not refer. It *is.*

The mask, *like the side-show freak, is mainly*

participatory rather than
pictorial in its sensory appeal.

THE MORE THE DATA BANKS RECORD ABOUT US, THE LESS WE EXIST

357

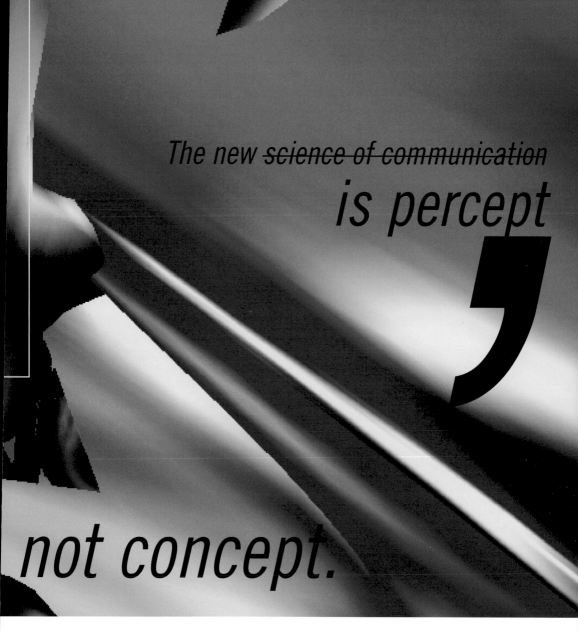

The new ~~science of communication~~
is percept

not concept.

The nuclear bomb will turn warfare into the juggling of images.

The POTENTIAL of
any NEW TECHNOLOGY
is always dissipated
by its users'
involvement in its
PREDECESSORS

Without an understanding of formal
causality there can be no THEORY OF
COMMUNICATION. What passes as
information theory today is not communica-
tion at all, but merely transportation.

The present is always invisible because it's environmental. No environment is perceptible, simply because it saturates the whole field of attention.

The professional tends to classify and to specialize, to accept uncritically the ground rules of the environment.
The ground rules provided by the mass response of his colleagues serve as a pervasive environment of which he is contentedly unaware.

The sculptural qualities of the image
dim down the purely personal identity.

The sociologist permits himself to see only what is acceptable

to his colleagues

The specialist is one who never makes small mis-
takes
while moving toward the
grand fallacy.

By electricity we have not
been driven out of our senses
so much as our senses have
been driven out of us.

Today man's nerves surround us -
they have gone outside as electrical
environment.

Violence is the effort to maintain and restore a weakened psyche.

Visual space is the space of detachment.
Audile-tactile space is the space of involvement.

War *has become the environment of our time* *if only because it is an accelerated form of innovation AND EDUCATION.*

War is never anything less than accelerated technological change.

We are swiftly moving at present
from an era when business was our culture
into an era when culture
will be our business

Between these poles stand the huge and
ambiguous entertainment industries.

We look at the present through a rear-view mirror.

We march backwards into the future.

World War I a railway war of
centralization and encirclement.

World War II a radio war of
decentralization concluded by the Bomb.

World War III a TV guerilla war with no
division between civil and military fronts.

the electric light
is pure information.

it is a medium without a message.

The human family now exists under conditions of lage. We live in a single constricted space resonant with

obal vil-

tribal drums.

These excerpts are not just references. They are structures that embody special kinds of perception and awareness.

Each is a kind of example or anecdote. Each is a kind of little world that has to be apprehended in depth.

For this reason it is not at all necessary to read them in any special sequence.

They are, however a mosaic, and, like a mosaic, they are not just to be seen, but to be perceived by all our senses.

Eric McLuhan and William Kuhns

Poetics on the Warpath

During his last years, when he was making his most exciting discoveries, Marshall McLuhan's critics were demanding that he provide 'more and simpler' explanations. They found it most difficult to grapple conceptually with the media and the events he was discussing. McLuhan, meantime, had been moving away from logical, expository prose, finding it both too cumbersome and ill suited to understanding the irrational workings of mew media forms.

The probe is a means or method of perceiving. It comes from the world of conversation and dialogue as much as from poetics and literary criticism. Like conversation, the verbal probe is discontinuous, nonlinear; it tackles things from many angles at once. So while the probes in these

pages are adapted to discovery and awakening perception and illuminating situations, they are not useful in exposition or logic, which calls for linear prose. The probe resists any single point of view. The probe is a better form than expository prose for examining our time because it works by gaps and interfaces. McLuhan wrote, in 1968, that one of the most obvious changes in the arts of our time has been the dropping not only of representation but also of the story line. In poetry, in the novel, in the movie, narrative continuity has yielded to thematic variation. Such variation in place of story line or melodic line has always been the norm in native societies. It is now becoming the norm in our own society and for the same reason, namely, that we are becoming a nonvisual society.

As a student at Trinity College in Cambridge, Marshall McLuhan learned 'practical criticism', a radical new technique for examining a text from several angles at once. Using probing questions instead of theory made it possible to approach any subject or situation in a way that afforded rapid insight. It was actually new only in the sense that it revived something that had long since gone out of fashion. The medieval scribe would interpret any text or situation from several directions at the same time. In addition to the literal sense, the medieval reader tuned in on the allegory beneath the surface event, and looked for moral significance or other kinds of meaning. Practical Criticism, an analytical approach developed at Cambridge

in the 1920s and 1930s, reintroduced multi-level interpretation. It asks the reader to scrutinize the literal sense, then to investigate things normally disregarded, such as the identity used by the speaker, and the relation between speaker and writer and reader. The book, *Practical Criticism* by I.A. Richards, aroused terror in the academic world of the time because it revealed that the best students and professors were quite incapable of reading ordinary poems and could not agree as to even what this or that poem meant. A potent technique, Practical Criticism quickly jumped out of the classroom and into everyday culture. It could be applied in every arena, highbrow and low: to the press, advertising, popular theatre and film, radio, concerts, art exhibits, new movements of every kind.

In the 1940s, Marshall McLuhan used Practical Criticism as the basis of a popular public lecture about contemporary culture. He would arrive armed with a tray of slides of ads, newspaper pages, book covers, etc., and a headful of poignant, probing questions. In response to audience suggestions, he eventually made it into a book, called *The Mechanical Bride*. A glance at any sample page shows the probe technique in the first blush of youth. The problem faced by any explorer, as he remarked later, is to invent tools (probes), not to make logical or connected statements. Because the probes in these pages are adapted to discovery and awakening of peception, what is said matters less than how the imagination is

stirred. In other words, an innacurate probe can work as effectively as one that is perfectly accurate.

Connected, sequential discourse, which is thought of as rational, is really merely visual. It has nothing to do with reason as such. Reasoning does not occur on single planes or in a continuous, connected fashion. The mind leapfrogs. It puts things together in all sorts of proportions and ratios instantly. To put down thoughts in coded, lineal ways was a discovery of the Greek world. It is not done this way, for example, in the Chinese world. But to deny that the Chinese have access to reason would be ridiculous. They do not have rational discourse at all by Western standards. They reason by the act of interval, not by the act of connection. In the electric age we in the West are moving into a world where not the connection but the interval becomes the crucial event in organization. McLuhan always found the interplay of aspects and viewpoints in dialogue led directly to discovery and to awareness of formal structure:

"This interplay of aspects can generate insights or discovery. By contrast, a point of view is merely a way of looking at something. But an insight is a sudden awareness of a complex process of interaction. An insight is a contact with the life of forms."

The sheer speed-up in innovation today had revived interest in the *forms* of the new media. As the consequences of change accelerate, it is easier to discern causes. Interest in formal causality seems to have declined after the sixteenth century, as did interest in analogy. But the artist picked up this interest where the philosophers left off and has always insisted on the formal (not just the efficient) causality of artifacts.

Formal cause has no common equivalent today: it meant something like 'the enveloping situation' or 'the pattern of cosmic influences' and it was related to the potency of the *logos*. It was above all concerned with patterns of influence and with side-effects, and is exactly related to what McLuhan meant by 'medium'. This twist may account for why some people have such difficulty understanding the phrase 'the medium is the message' or the pun it inspired 'the medium is the massage'. Each medium is the *logos* of a technology, and is certainly the massage *and* the message that it holds for the user culture. To say this is to equate formal cause with logos, an ancient understanding of the power of language and the language of power structures.

All media have a verbal structure. Creation and innovation were considered close cousins of language and naming. So Plato, in the 'Cratylus' observes that 'a power more than human gave things their first

names.' And that Adam's first job in the Garden was *naming* recognizes the complementarity of creation and knowing through words: the logos. In Aristotle's time, the understanding of logos had shifted to the new specialized meanings in tune with alphabetic thinking. The older meanings were wrapped up with power and definition and structure; the new meanings were more concerned with detached rationality, rational plan, report, etc. Another word appeared to take up the slack dropped by logos in the transition: *mythos:* myth.

Aristotle proposed four modes of causation, which he called formal cause, efficient cause, material cause, and final cause. The most troublesome of the four, even to Aristotle, is formal cause. The other three are fairly straightforward. The material cause of any book, for example, is the physical matter: paper, glue, bleach, ink, etc. The efficient cause includes everything and everyone that played a part in its manufacture: efficient cause is inevitably a sequential process. The final cause is this book itself as an artifact, in and of itself. But the formal cause, *which includes all of the other causes simultaneously,* is a very different kind of matter. It includes all of the side-effects of The Book. It includes literacy, and the phonetic alphabet. The largest component of the formal cause of this book, or any book 'The Book' is the single reader and the reading public. Equally, the formal cause of a poem, or a painting, or an advertisement, or a

labor-saving device, or any technology, is the entire *ground* of the item, particularly including the user. Understanding Formal Cause helps considerably in understanding what McLuhan meant by 'medium'. The reader wears the mask of the author's work as a way of seeing, even as the author puts on the public as a mask. One is probe for the other. Both are clichés. Joyce compressed it into a phrase: "My consumers, are they not my producers?" The same reciprocal and complementary tension exists between McLuhan's words and David Carson's images in this book. Each is a pattern or vortex of energy designed to let the reader perceive a field of action that would otherwise be outside his ken.

* * *

Several books McLuhan wrote in the 1960s and 1970s explored new uses for the technique of the probe. *Culture is Our Business* was written to examine North American advertising after television, to contrast the study in *The Mechanical Bride* of ads and popular culture before TV. *The Gutenberg Galaxy*, much more academic in tone and style, used statements in bold type to interrupt and to probe the passing text. Of the profusion of quoted passages in the text, McLuhan remarked, "The literary quotations I use in the *Galaxy* are not intended as footnotes or as part of my argument. They are

there as heuristic probes. I could substitute for any one of those quotes twenty or thirty other citations." He had begun to invent a new and subtly different kind of prose.

Through the Vanishing Point: Space in Poetry and Painting carried the technique of discontinuity to an entirely new level. Each chapter juxtaposed a poem and a painting—generally not from the same period—and often from quite different cultures. Each art is used to probe the other. For example, Chapter 39 places 'Chanson Innocent' by e. e. cummings opposite Paul Klee's 'The Twittering Machine'; Chapter 14 places lines from Malory's 'le Morte d'Arthur' opposite a 16th-century Persian map of the world. Moreover, the page facing each poem and each painting consists of a set of probes. Chapter 2 juxtaposes a 'one-image poem' by Ezra Pound with the Chinese character for speech (printed upside-down].

The climax of the probing and questioning technique was reached in *Laws of Media: The New Science,* Marshall McLuhan's last book. We had discovered that there were invariably four general patterns to the effects of any new technology, and that they resonate in proportion to each other: A is to B as C is to D, the structure of all metaphor. These four features give the logos, the complete pattern of forces of any new technology. Not only did these four appear in the case of technologies like radio and print, but also

they applied to every human artifact of whatever kind, including clothing, styles in art, literature, music, philosophical systems, and even laws of physics and chemistry, or civil laws or parts of speech.

Introducing the book, *The Bias of Communication,* McLuhan credits Harold Innis with having discovered the 'method' of using historical situations as a laboratory in which to test the character of technology in the shaping of culture. He had been using the same technique himself for some time before locating it in Innis. He wrote, in 'The Emperor's Old Clothes,' that the way a technology intrudes into a society can suddenly illuminate unexpected relations between things (forms) normally regarded as quite separate:

> "It does help to look at the newspaper as a direct, exploratory probe into the environment. Seen in this light, there is more meaning in the aesthetic bonds between the poet, the sleuth, and even the criminal. For James Bond, Humphrey Bogart, Rimbaud, and Hemingway are all figures who explore the shifting frontiers of morals and society. They are engaged in detecting the social environment by probing and transgression. For to probe is to cross boundaries of many kinds; to discover the patterns of new environments requires a rigorous study and

inventory of sensuous effects. The components of new environments cannot be discovered directly. Edgar Allan Poe's detective, Dupin, is an aesthete. The aesthetes were the first to use the senses consciously and systematically as probes into the environment. Walter Pater's injunction, 'To burn always with a hard gem-like flame,' referred to the action of the plumber's blowtorch, a technical invention of his day."

When he began to experiment with the probe technique to sharpen awareness, McLuhan stumbled on how one cliché works to probe other clichés, especially media as clichés. This led him to realize that all forms and formal structures are clichés. The cliché need not necessarily be verbal: "it is also an active, structuring, probing feature of our awareness. It performs multiple functions from release of emotion to retrieval of other clichés from both the conscious and unconscious life. Its real significance lies in the fact that all access to consciousness is tentative and uncertain. The simplest definition of cliché is a 'probe' (in any of the multitudinous areas of human awareness) which promises information but very often provides mere retrieval of old clichés".

How, then, does the probe or cliché manage to retrieve formal awareness? Is it not natural that, as any form whatever becomes

environmental and unconscious, it should select as 'content' the most common and vulgar and environmental of materials? As any form becomes environmental, it tends to be soporific. That is why its content must also become innocuous in order to match the effects of the medium. Any medium whatever, as it becomes pervasive, is to that degree common and vulgar and therefore attracts and demands only common and vulgar materials. To the artist this vulgarity is an opportunity so far as he is competent to set it in opposition to another equally pervasive form. Since the artist is typically interested in revealing forms, he never balks at contact with the most vulgar materials. The banal, as such, is loaded with energy for the artist with the skill to release it: for it requires encounter with another cliché. Media themselves can act as probes that force other media to reveal their natures. The kinds of probe are many and poetics—poesis—extends beyond poetry. Art-as-probe is survival.

Probes belong to that less civilized and more ancient poetics that includes myth, magic, and aphorism. The essay aims to expound, explain, convince; the probe to reveal, prod, irritate, or provoke discovery. Myth gives a succinct statement of a complex social process that has occurred over a period of centuries. Like myth, the probe is a contemplative's instrument. More than simply a striking statement, the probe juxtaposes forms and situations that prod the reader or user into awareness and

insight. Like myth or aphorism, each probe is an essay compressed into a few words. Decompression—in the form of sudden insight—calls for wit and agility and the patience to mull something over for hours, or days, or longer. A good probe is hard to exhaust. It does not surrender everything at first encounter any more than a line of poetry does. The best poets have the same hard-won gift for compression. Each of McLuhan's probes invites similar prolonged meditation and exploration.

Discussing the work of Harold Innis, McLuhan here seems to tell us the best way to approach his own work:

> Each sentence is a compressed monograph. He includes a small library on each page, and often incorporates a small library of references on the same page in addition. Most writers are occupied in providing accounts of the contents of philosophy, science, libraries, empires and religions. Innis invites us instead to consider the formalities of power exerted by these structures in their mutual interaction. He approaches each of these forms of organized power as exercising a particular kind of force upon each of the other components in the complex. By bouncing the unknown form against known forms, he discovered the nature of the new or little known form."

At the peak of its form, the probe is poetry on the warpath, an active and aggressive poetics intended to arouse awareness of a situation. A probe is not for passive consumption but for active prodding and needling and causing the user to discover many levels of action and influence in interrelation. Humor and playfulness is basic to McLuhan's probing, aphoristic associating of incongruities. His "technique of discovery," using the Symbolist art of juxtaposing forms, lends itself everywhere to a series of dramatic surprises. He applies artistic methods directly to the materials and circumstances of everyday life. He had discovered how to apply the formal sensibility of the artist outside the realm of art. Three years after *Understanding Media* appeared, McLuhan remarked,

"… Throughout my work, however, I am saying that awareness is being pushed more and more out into the environment. Art becomes environment. Our environments are made of the highest levels of human consciousness. Most academics and specialists in cultural and social study try to reinforce that barrier. All the types of specialized and linear approach to situations past, present or future are now useless. Already throughout the sciences there is recognition of the need for a unified field theory which would enable scientists to use one continuous set of terms to relate the various scientific universes. In other

words, the way of thinking and perceiving is vastly more important in these matters than the actual content of the thought. Literally, *Understanding Media* is a kit of tools for analysis and perception. It is to begin an operation of discovery. It is not the completed work of discovery. It is intended for practical use. Most of my work in the media is like that of a safecracker. In the beginning I don't know what's inside. I just set myself down in front of the problem and begin to work. I grope, I probe, I listen, I test, until the tumblers fall and I'm in. That's the way I work with all these media."

Further:
"I'm perfectly prepared to scrap any statement I ever made about any subject once I find that it isn't getting me into the problem. I have no devotion to any of my probes as if they were sacred opinions. I have no proprietary interest in my ideas and no pride of authorship as such. You have to push any idea to an extreme, you have to probe. Exaggeration, in the sense of hyperbole, is a major artistic device in all modes of art. No painter, no musician ever did anything without extreme exaggeration of a form or a mode, until he had exaggerated those qualities that interested him."

One man who had inspired McLuhan since his Cambridge days, Francis Bacon, had also exploited the 'power of writing in aphorisms.' Like Pound, contrasting the teacher and the lecturer, Bacon noted that smoothly polished, connected prose acted on the mind as a soporific and gave the impression that there was nothing more to learn. All was known, every inconsistency made smooth, every gap filled. Aphorisms, or probes, by contrast, being brief, pungent, discontinuous, Bacon called "knowledge broken": because incomplete, they invite people to dig deeper and to close the gaps. The connected statement is "more fitted to win consent or belief"; the probe, "to point to action" and discovery for oneself.

> Bacon:
> "But as young men, when they knit and shape perfectly, do seldom grow to a further stature; so knowledge, while it is in aphorisms and observations, it is in growth; but when it once is [rendered in connected prose], it may perchance be further polished and illustrate[d] and accommodated for use and practice; but it increaseth no more in bulk and substance."

Bacon makes it perfectly clear that he considered his own aphoristic style an integral part of a scientific technique of keeping knowledge in a state of emergent evolution. On these same grounds, McLuhan found the

'probe' style preferable to that of conventional explanation. It provides a way to train sensibility and coax experience into revealing its patterns, much like instant replay: The instant replay is less concerned with the input of experience than with the process of perception. The instant replay, indeed, offers not just cognition but re-cognition, and leads the mind to the world of pattern recognition, to aftersight and foresight.

Every dominant technological or social or cultural form, together with all its causal powers, is always hidden from that culture by a process of protective inhibition: these forms are so total, so environmental as to become invisible. They resist every ordinary effort to notice or investigate them. Thanks in part to the perceptual training afforded by Practical Criticism, McLuhan had discovered a means of using historical situations to reveal the present. He reports that Innis made the same discovery:

> "Innis taught us how to use the bias of culture and communication as an instrument of research. By directing attention to the bias or distorting power of the dominant imagery and technology of any culture, he showed us how to understand cultures. Many scholars have made us aware of the 'difficulty of assessing the quality of a culture of which we are a part or of assessing the quality of a culture of which we are not a part.' Innis was perhaps

the first to make of this vulnerable fact of all scholarly outlook the prime opportunity for research and discovery. At a stroke he had solved two major problems that are forever beyond the power of the 'nose-counters' and of statistical researchers. First, he knew what the pattern of any culture had to be, both physically and socially, as soon as he had identified its major technological achievements. Second, he knew exactly what the members of that culture would be ignorant of in their daily lives. What has been called 'the nemesis of creativity' is precisely a blindness to the effects of one's most significant form of invention."

In a traditional society, art functions not to orient the population to change but to help it preserve its integration with the natural world and the cosmos. A similar instinct underlies much of today's ecological partisanship. In *The Book of Tea,* we are told that the purpose of art is to accommodate men to the changing present. Such too was our condition before we adopted writing. Writing introduced the Royal Divorce between the eye and the other senses. The age of printing and the machine extended and intensified the divorce between man and nature, knower and known. They became engines for retrieving Nature, and the past, as idealized experiences. Nature and past times served as fecund sources

for aesthetic consumer products and pastimes. Art in traditional society focuses instead on dissolving any divorce between outer and inner experience. In our era of sustained and rapid environmental change the natural reaction is numbness. Any attempt to adjust to these extremes produces a kind of robotic response as they program and reprogram us in quick succession. Wyndham Lewis, realizing this, proclaimed, "the well-adjusted man is a robot." So the arts have reversed their traditional function from integrating, which leads to a kind of mechanistic death, to rectifying sensibility by providing counter-environments. The tendency, that is, of the artist is to become a probe into his own society. "Artists are the antennae of the race." As antennae, artists probe the living environment and pluck fresh intuitions right out of it. The artist resists the soporific influences of the hidden or enveloping environment, instead coaxing perceptibility by providing "counter-environments." Artists have to probe to discover anything: our technologies are generations ahead of our thinking. When any culture ignores the perceptions of its artists, it atrophies.

Beginning with the Romantics in the nineteenth century, at least as much as the scientist, the artist began to use his senses and his art as a laboratory means of investigation. The antisocial aura of the scientist and the artist tended to fuse, as the century moved on, with the image of the criminologist. Poe's Dupin is an aesthete and an integral investigator,

like Poe himself and the symbolists in general. The solution to the numbing effect of rapid social change is the art probe's shock of recognition and sting of perception. All serious art of the 20th and 21st centuries consists of clichés and probes where that of previous centuries had been archetypes. The flat cliché is an enormously richer and deeper form than anything that can be managed by verbal realism and the most delicate shades of meaning. It is the same in all the arts. The flat icon has multitudinous layers of significance whereas the three-dimensional perspective illusion necessarily specializes in one facet at a time.

In our time, the effect of the space station and the satellite has been to convert the planet itself into a probe: the capsule and the satellite have created a new environment for our planet. The planet is now the content of the new spaces created by the new technology. Instead of being an environment in time, the earth itself has become a probe in space. That is, the planet has become an anti-environment, an art form, an extension of consciousness, yielding new perception of the new man-made environment. Whereas the mechanical environment turned the old agrarian world into an art form, the electric technology enables us to mime or simulate the old planetary environment in our capsules. As Buckminster Fuller has pointed out, "the rocket capsule that will keep man living successfully in space for protracted periods . . . will be the first

scientific dwelling in history." Science, quite as much as art, is concerned with the construction of anti-environments. In the electric age the anti-environments of science incorporate the nervous system. They become 'responsive environments,' or probes. With electric circuitry we cannot only program the entire environment responsively as a work of art, we can include the learning process in the environment itself.

Today, the Internet and world-wide web present all the world's cultures and times as simultaneously present. There are far too many clichés available for retrieval. Since this technology extends consciousness itself, we probe all, and scrap all in a deluge of fragments of cultures for creativity. As a consequence we now live amid a massive, multifaceted global renaissance in which each individual culture is a local idiom. Gone is any vestige of unified consciousness; the world now turns in multiconsciousness. Any culture, local or global, naturally acts as a kind of tacit propaganda environment for programming its users' uncon-sciousness; and an environment is far too unwieldy a thing to be usable as a probe. Yet the art materials shaped by a single artist can serve as probe to direct and order perception. Serious art is counter-propaganda, and McLuhan's probes are counter-environmental.

* * *

Neither illustrations or decoration or graphic captions, David Carson's paintings make no attempt to repeat graphically their verbal counterpart. Instead, they counterpoint with the text and provide a complex dialogue that plays on the reader's sensibilities. They have exactly the right effect. The words of W. B. Yeats provide an inkling of Carson's procedure:

> Those masterful images because complete
> Grew in pure mind, but out of what began?
> A mound of refuse or the sweepings of a street,
> Old kettles, old bottles, and a broken can,
> Old iron, old bones, old rags, that raving slut
> Who keeps the till. Now that my ladder's gone,
> I must lie down where all the ladders start,
> In the foul rag-and-bone shop of the heart.

The human sensorium in all its civilized complexity remains a 'center of paralysis' until prodded and probed by verbal or artistic energies. The dominance of one sense is the formula for hypnosis. The sleeper awakes when challenged in any other sense. David Carson's images complement McLuhan's probes by multiplying the reader's meditative capacities. They act as counter-environment. Although the elements of this collaboration

were conceived continents apart and separated by many years, they interact in almost ideal harmony.

Introducing a book about one of his favorite authors, G. K. Chesterton, Marshall McLuhan wrote the following lines: "It is important that a Chesterton anthology should be made along the lines indicated by Mr. Kenner. Not an anthology which preserves the Victorian flavor of his journalism by extensive quotation, but one of short excerpts which would permit the reader to feel Chesterton's powerful intrusion into every kind of confused moral and psychological issue of our time." These words seem to apply to this bouquet of short excerpts, which we have culled from every aspect of McLuhan's writing. In the same spirit, we offer this collection, this anthology of probes.

A final note. For years, a small handlettered sign hung on the West wall of Marshall McLuhan's Centre for Culture and Technology at the University of Toronto. It read:

The important thing is to acquire perception,
though it cost you all you have.

W. Terrence Gordon

THE BOOK OF PROBES

*McLuhan's words are about words,
and Carson responds with a map
about maps.*

When a copy of *Adbusters* spoofing the double-cover technique for
magazine design reached me, I wondered what McLuhan would have to say
about it. He often proclaimed advertising to be the art form of the
twentieth century; would he condemn *Adbusters* as heresy or relish this latest
issue with its pungent satire of virtual newscaster Ananova and her living
doppelgänger? I did not have to wait long for the answer, because the same
day's mail brought me a pre-publication copy of *Marshall McLuhan: The Book*

of Probes. Reading just a few pages was enough to start a feedforward from the probes to a McLuhan disquisition on a phenomenon unknown to him: ananova.com. Image...sharper definition on the page than on the computer screen...media effects...photo of woman made up like Ananova flips real to virtual...Reaching these closing pages, you are ideally placed, as I was, to take the small step/giant leap from the McLuhan galaxy of thought-tools to interpreting the phenomenon of Ananova herself, the *Adbusters* parody of her, or the cultural significance of *any* fragment of news that she may deliver.

Page 392 of the *Book of Probes* gives us one of the two best-known phrases in the author's work. Like its rivals for instant recognizability as vintage McLuhan, *the global village* expresses a paradox, but without the unsettling, counter-intuitive quality of *the medium is the message*. We easily interpret the metaphor for our planet shrunken by the conditions of modern life. For this we scarcely need McLuhan. But if we scrutinize the context (for him an indispensable first step in any analysis), the two-sentence package of the first probe, we discover that it is as resonant as the global village itself, *conditions, space, resonant,* and *tribal* being key words throughout our author's work.

What cognitive alchemy do they hold for the man who once signed

himself "medium-mystically yours, Marshall McLuhan?" 1) *Conditions.*
Understanding depends on stepping back from any situation far enough
to get the connections that ensure understanding. McLuhan jump-starts
that step back by fashioning his probes so as to make us ask ourselves
questions: if the human family *now* exists under conditions of a global village,
what were the previous conditions—the conditions prevailing when the
globe consisted of isolated villages? How did those conditions change and
with what effect? 2) *Space.* If the human family lives in a single constricted
space, a village with dimensions little larger than those of a prisoner's
cell, is no escape possible? If it is possible, how does McLuhan show us the
way? 3) *Resonant.* What *is* inescapable is the sound environment in which
we live, but this is not our prison unless we let it be; on the contrary, it is
a means of escape if we listen for what? 4) *Tribal drums.* Here is the link
to resonance, to the notion of the resonant utterance (see below), and to
the author who influenced McLuhan so profoundly with his vision of the
western world retribalized by electric technology—James Joyce. And so
McLuhan asks us to develop our own program (or "probe-gram") from
the pregnant echos that form from page to page of this book. The seeds of
the probes spring up with the beauty of unexpected cactus flowers, linked
to each other in what the French symbolist poet (*symbolism* means *resonance*)
Charles Baudelaire called a deep and shadowy unity. *Global village* and
the medium is the message are mutually illuminated in this shadowy unity when

McLuhan offers *it is the medium that shapes and controls the scale and form of human association and action*.

The Book of Probes requires that we do much work for ourselves. A probe is a prod, a call to action, and only rarely does McLuhan offer us what one of his mentors, I. A. Richards, called *vertical translations*, paraphrases that confirm comprehension. We are grateful when we read *to say that any technology or extension of man creates a new environment is a much better way of saying that the medium is the message*. But McLuhan thought of himself as an explorer more than an explainer; to show himself more than occasionally as a reader of his own work would be to blunt the probes and stifle the complicity with us requisite to his method and his educational aims. Baudelaire addresses his "hypocritical" reader as a kindred spirit and a brother; McLuhan invites us as intellectual kin into the hypercritical reading of his probes. Why did he prefer the probe to the essay? A probe *is* an essay, but with the "edge, strength, and pressure" of which McLuhan speaks in defining it, a new form for an old tool, an intellectual tool for examining everything from other intellectual tools to the hardware and software that shape any society and all civilization.

Unlike the spines of a cactus in their tidy rows, McLuhan's prickly probes zigzag across a vast thoughtscape. Following him, keeping up with

him, we have no time to rest or recognize a new location before he beckons us to move on. David Carson comes to our rescue. As translation into the local idiom and bearings for our current whereabouts, his art work roots us for a moment, even as McLuhan pulls us ahead. But Carson does not deliver comforting postcard views; his visual mosaics can leave us just as breathless as the punches of McLuhan's prose. Snap and shot, but no snapshots from either artist or writer.

The McLuhan-Carson partnership works constantly to turn symbiosis into synergy. A rich example comes in one of the many probes exploring the connection between world and word: *The space of early Greek cosmology was structured by Logos — resonant utterance or word*. McLuhan's words are about words, and Carson responds with a map about maps, giving us both insights into how maps are fashioned *from* language and an imaginative map *of* language.

Carson is every bit as playful as McLuhan. The ground of his visual rendering of the Logos probe (54-55) is all medium and no message—the very idea explored in later pages. The pure white, lower right corner of the page is given an ethereal quality by what appears to be light filtering through a high window into a space simultaneously enclosed and unbounded. It provides a haven of rest for an eye exhausted by the price it pays for its

addiction to linear space—traversing the riotous clutter of forms, strident red and pink patches, needles, and wedges, that dominate diagonal movement from the upper left, yielding to softer, pink-edged pouches of blue only at the center, once Logos has worked its effect. But before he gives us that visual balm, Carson tweaks the nose of our eye with a wake-up call to resonant utterance, scattering visual reminders of how we impoverish our sensory lives by clinging to linearity. There can be no linear Logos, as the thin yellow L bent beneath the weight of the heavy black one above it shows us. And when the geometer comes to stake a territory in the pure white flow of this Logos tableau, his vertical axis bounces back against itself, and the horizontal one is scarcely begun when it runs off the page. There could be no more potent visual translation than Carson's of the James Joyce pun on the word *alphabet*—**allforabit**—so often used by McLuhan to teach that the orderly, rational, linear, horizontal world created by the dominance of the phonetic alphabet robbed mankind of the riches of a yesterworld suffused by Logos. Even the standard X/Y coordinates of geometry are deconstructed by the Logos; Y is literally hung by the symmetry of X, vanishing at the upper edge of the righthand page. We cannot be sure if it has been undone by redundancy or ambiguity, the Scylla and Charybdis that loom for the navigator of logic, though not for the knower of Logos. The shards of the fragmented *s* linked to the integral **Logos** cannot be reassembled to make the letter whole, but both

its fragments and its missing pieces are defined in part by a vertical linearity. This is the aborted axis from the geometric diagram to the right, rehabilitated by its new function of mutually flipping figure and ground. The flip reconfigures the shattered *s*. A single stroke restores the unity of the Logos, its muted eloquence retrieves its voice and regains its force.

The Book of Probes is perhaps most profitably mined by focusing constantly on its recurring and integrating features as well as some of the reading strategies already hinted at—and extending them.

1) If *conditions, space, resonant,* and *tribal* are weighted with meaning for McLuhan and the keys to mastering his method, the same is no less true for other seemingly transparent and even inconsequential words of common currency to which a reader must be alert. Take *or* in the following probe: *The content or time-clothing of any medium or culture is the preceding medium or culture.* The arresting metaphor of time-clothing can distract from *or*, functioning first to teach us that there can be no such thing as content unless time has cloaked an older medium in a new one and secondly to remind us that we impoverish the scope of McLuhan's probes unless we remember that the notion of medium extends to every human endeavor and its consequences for social organization. The first *or* also shows us the important distinction between content and message.

2) McLuhan gives us surprising combinations, and the combinations bring us back to his fundamental principles in probes such as the following: *Sentimentality, like pornography, is fragmented emotion — a natural consequence of a high visual gradient in any culture.* If we are willing to concede this bold claim for the connection between the visceral and the visual, we still expect some inviolable logic to keep sentimentality and pornography poles apart. But McLuhan's logic is dictated by the inviolable laws that he distilled from decades of reflection on the operation of all media. The key words in the present probe are *fragmented* and *visual*, fragmentation and visual bias being the principal effects fostered by the development of the phonetic alphabet and later by the invention of print technology. McLuhan set out this basic lesson in *Understanding Media* in 1964, but it is already clear more than a decade earlier in *The Mechanical Bride*, with its illustrations of the female body fragmented over and over in advertising. They inevitably strike us as less violent and less offensive than hard-core pornography, but for McLuhan both are examples of the sensory life of mankind skewed by specialist intensity. In sentimentality, McLuhan sees the same principle at work, reducing a rich range of emotions to bathos. And this is why another probe tells us: *The age of writing has passed. We must invent a new metaphor, restructure our thoughts and feelings.*

3) Though McLuhan seldom gives us a *because* (*The present is always invisible*

because it's environmental. No environment is perceptible, simply because it saturates the whole field of attention), he gives us much about cause and effect, a crucial pair of terms in the mosaic of his probes. He links his observations on cause/effect to language *(The right word is not the one that names the thing but the word that gives the effect of the thing)*, to music *(The electronic age is a world in which causes and effects become almost interchangeable, as in music structures)*, and to other key terms in his analytical tool box—perception/conception *(Effects are perceived, whereas causes are conceived)*, figure/ground *(Ground cannot be dealt with conceptually or abstractly—it is ceaselessly changing, dynamic, discontinuous, and heterogeneous, a mosaic of intervals and contours)*. The lesson emerges, once again, that understanding and assimilating McLuhan's ideas depends on detecting the coherence of his probes.

<p align="center">* * *</p>

If reading *The Book of Probes* fosters the habit of asking questions, we may ask finally what constitutes the irreducible essence of a probe? Once again, we find that McLuhan forces us back on our own resources, our own initiative, our capacity for the reader involvement he demands, if we ask the question about what appears to be one of the least probe-like of his pronouncements: *Native societies did not think of themselves as being in the world as*

occupants but considered that their rituals create the world and keep it operational. This is not a historical note, despite the rare past tense. It might seem not to be a probe at all, because it is not about us. But it proves to be as much of a call to reflection/action as any unmistakable McLuhan salvo, when we recognize that non-native societies *do* think of themselves as occupants of the world. What rituals are we conscious of in our society? Why do we not think of them as creating the world and keeping it operational? And so the answer to our original question is that whatever observation begets questions about whatever aspect of our cultural lives creates a probe.

We may reread *The Book of Probes* any number of times with the objective of coming to a better understanding of our world, but we should also savor it for its own richness. In these pages we meet the didactic McLuhan who discourses on *mimesis of the alphabet*, the McLuhan of economical eloquence (*The phonetic alphabet forced the magic world of the ear to yield to the neutral world of the eye*), the poetic McLuhan who speaks of *acoustic spill*. And the whimsical McLuhan: *Each technological extension involves an act of collective cannibalism. The previous environment is swallowed by the new environment and reprocessed for whatever values are digestible.*

Whether it is language and the wheel, vernaculars and games, bulldozers and linguistics, or the movies, Scott, and Tolstoy, McLuhan is

forever making unexpected comparisons. I picture him making a less surprising comparison today between the mechanical bride and Ananova, simply as confirmation of his observations on the contrasts between mechanical and electronic technologies and their effects. When Marcel Duchamp created the original mechanical bride, the full name of the painting in which she appears tells us that she was stripped bare by her bachelors. In McLuhan's book of the same name, she falls victim to the fragmenting effect of the specialization that began with Gutenberg and culminated in the assembly line. The electronic age produces the ultimate form of violence—what McLuhan once called a gigantic ripping off of the flesh, because our central nervous systems are now externalized. There is a deliberate ambiguity to the probe that tells us that *the most human thing about us is our technology*, but none whatever when we read *Today man has no body*. The second part of this probe makes it clear that it is no hyperbole: *He is translated into information, or an image. Mass man is a phenomenon of electric speed, not of physical quantity.* This is the new bride, not stripped, not fragmented, but transformed into the ethereal Ananova.

Like all inhabitants of the global village, she has no body. O brave new world that hath no people in it, Shakespeare would need to say today, refashioning his original saying from the archetype where it has languished since the Orwell title that reduced it to a cliché. Shakespeare's artist's

radar would serve him instinctively to share McLuhan's percept of electric hegemony conjuring flesh and blood out of existence, a percept that flies in the face of a pricked finger or a rash—though not of a pierced navel or a full-body tattoo.

The bravery that Shakespeare spoke of McLuhan invites us to summon by surveying with calm detachment the face of chaos. Edgar Allan Poe's sailor in *A Descent into the Maelstrom* saved himself from annihilation by scrupulous observation of his environment, by detecting patterns of movement in surroundings that were overwhelming him and drawing him to certain death. It is too late to avert the annihilation of the era in which we lived wholly inside our bodies, but not too late to avert spiritual death. Like Poe's sailor, we cannot avoid being inundated by the powerful forces of the culture and technology that make up our environment, but we can look at their effects and form strategies for controlling our destiny in the midst of the electric maelstrom. When we are faced with information overload, McLuhan tells us, the key to understanding is pattern recognition. *The Book of Probes* offers us that key.

W. Terrence Gordon

McLuhan and Saussure

McLuhan searches for semiotics beneath semiotics,
levels of meaning beyond the messenger's intent
or the recipient's awareness.

— Philip B. Meggs

In the early 1970s, after years of trying to satisfy his curiosity about linguistics, Marshall McLuhan finally turned to the pioneering work of Ferdinand de Saussure and his Course in General Linguistics. When he reached page 16, it was not the author's highlighted definition of semiotics that caught his eye (the science that studies the life of signs within society), but the passage following it. There, linguistics is described as only a part of semiotics. Saussure confidently predicts that universal laws of semiotics

will be discovered and would prove to be applicable to linguistics. McLuhan's initial note on the passage says simply 'media?' But the floodgates were open. By the time he was a third of the way through the book, he was noting 'LOM' (Laws of Media) over and over and listing the passages where Saussure's groundwork buttressed the emerging synthesis of ideas that McLuhan would articulate first in 1977 and fully explore in the posthumously published Laws of Media (1988).

The appeal for McLuhan of Saussure's program and of his method lay in his own very similar impulse to constantly broaden the scope of any intellectual inquiry, particularly into language. Saussure's proposal was to set linguistics in the larger context of semiotics. This was a procedure that simultaneously dictated an innovative approach to linguistics and offered the prospect of verifying the validity and rigor of the innovations. Even before reading any further, McLuhan was probing the link between Saussure's treatment of language and semiotics with his own pairing of language and media. In his copy of the Course in General Linguistics McLuhan noted: "A lang[uage] as medium includes its effects and service env[ironments]".

All of McLuhan's writings are explicit on the matter of the effects of new technology and the environments they create. The Romans had

wheeled chariots, but they did not have the sprawling cityscapes of the infinitely more ubiquitous and powerful wheels of the automobile.

All media of communications are clichés serving to enlarge man's scope of action, his patterns of association and awareness. With respect to language itself, the probes make it clear why McLuhan saw a connection between his media analysis and Saussure's framework of linguistic analysis, and why that compatibility was a basis for expanding and consolidating the implications of his own work:

> Language does for intelligence what the wheel does for the feet and the body. It enables them to move from thing to thing with greater ease and speed and less involvement.

Page 17 of Course in General Linguistics must have captivated McLuhan entirely with its very rich echo of McLuhan's observation about media as hidden environments:

> Saussure
> For the distinguishing characteristic of the sign, but the one that is least apparent at first sight, is that in some way it always eludes the individual or social will. In short, the characteristic

that distinguishes semiological systems from all other institutions shows up clearly only in language where it manifests itself in the things that are studied least, and the necessity or specific value of a semiological science is therefore not clearly recognized.

McLuhan
The hidden aspects of the media are the things that should be taught because they have an irresistible force when invisible.

This first encounter with Saussure was a compelling invitation to fully integrate his media studies with semiotic science. It echoed both his view of media and his concept of language. *Understanding Media* had explicitly stated that language was mankind's first technology for letting go of the environment in order to grasp it in new ways. There could be an easy accommodation between his principles of media analysis assembled and integrated from extremely disparate sources with what he found in Saussure's Course in General Linguistics.

When Saussure urged the study of rites, customs, and the like as signs, in the belief that this approach would 'throw new light on the facts and point up the need for including them in a science of semiology and explaining them by its laws,' McLuhan sensed the prospect of pressing this

approach into the service of laws of media. He saw a direct connection to a principle around which he had already been developing his studies: formal causality. Saussure's call to read rites and customs and other manifestations of cultural organization and social patterns as signs meant, for McLuhan, reading them as structures or formal causality. Saussure's definition of the sign, and the parameters he set for a full-blown program of semiotics to complement linguistics, accommodated McLuhan's orientation to media analysis, holding the promise of discovering a semiotic dimension to his method.

This did not mean that McLuhan was on his way to hijacking semiotics for media studies, nor did it mean that he was on his way to becoming either a declared or covert practitioner of semiotics. It is possible to cite at least one of his publications predating both his reading of the Course in General Linguistics and the publication of *Understanding Media*, where he focuses very specifically on one of the most fundamental issues in semiotics: when does a mechanical code of transmission itself become a language?

Nearly twenty years before immersing himself fully in Saussure, McLuhan published 'Media Fit the Battle of Jericho' evoking the rudimentary semiotics of animal languages, the incantory power of language before writing, and the effect of writing on the dynamics of the spoken

word. His probes there invite readers to move with him to the bold conclusion that all languages are mass media, so the new media are new languages. This is the germ of the idea that would be introduced only casually, almost incidentally, in *Understanding Media* but then constitute the entire focus of Laws of Media. Between the publication of the two books, the idea had taken root in the soil of Saussure's linguistic and semiotic framework of thought.

In 'Myth and Mass Media' McLuhan launched the probe that would earn him a place in *Bartlett's Famous Quotations*. Inevitably the simple but dazzling rhetoric of 'the medium is the message' would overshadow McLuhan's explication of that sentence, which he linked to form and formal causality:

> The formal causes inherent in media operate on the matter of our senses. The effect of media, like their "message" is really in their form and not in their content.

Equally obscured, in the same context, was McLuhan's definition of myth, virtually wed to the definition of the word as sign, as formulated by Saussure:

As a word uttered is an auditory arrest of mental motion, and the phonetic translation of that sound into visual equivalence is a frozen image of the same, is not a myth a means of static abstraction from live process?

McLuhan moved toward his conclusion with a call for a study of media ecology via linguistic means. At this time, Saussure was not even in his footnotes; eventually he would provide a methodological benchmark against which McLuhan could organize and test his laws of media.

After reading Saussure, McLuhan declared that all media are in the plenary sense linguistic. This semiotically grounded approach launched by Saussure in the first decade of the twentieth century had come a long way since the publication of the *Course in General Linguistics*. McLuhan had explained in 1960 how the structural linguistics derived from Saussure by his followers could be wrong. He stated plainly that his own approach was 'not derived from the recent field of structural linguistics' [but] from the practice and criticism in the field of poetry and painting during the past 100 years.'

But when McLuhan made his own close reading of the *Course in General Linguistics*, he saw the profound unity and coherence of Saussure's

thought. By that time, structural linguistics had begun to move into eclipse. Saussure's ideas were marginalized in linguistics and had already begun to be grotesquely misrepresented in the labyrinth under construction under the name of deconstruction. Laws of Media would not be published for more than a decade; the stunning discovery of a cache of Saussure's manuscripts was more than two decades away. The latter hold few clues to an obscure intellectual puzzle that preoccupied Saussure for years. As McLuhan 'searches for semiotics beneath semiotics', so Saussure sought to uncover signs operating at powerful, subliminal levels in the text.

McLuhan's search and Saussure's search illuminate each other in many ways, because of the thread of semiotic reflection that links them. That illumination has not yet penetrated the dreary world of deconstruction in its too many guises, but the resonances found between McLuhan's work and Saussure's may yet banish the shadow world of Plato's cave.

The New Science of Communication

Percepts : Fragments

A frontier is not a neighborhood. It is a gap, a ferment, an interface.

A mass medium is one in which the "message" is not directed at an audience but through an audience. The audience is both show and the message. Language is such a medium, one that includes all who use it as part of the medium itself.

Ads are like the weird faces or masks used by witch doctors to control the powers of nature. If one is merged in the tribal horde, that mask will look good to him.

Advertising is anonymous, like any folk art, and is the product of all the public skills of the community.

All human tools and technologies, whether house or wrench or clothing, alphabet or wheel, are direct extensions, either of the human body or of our senses.

All invention is a form of bodily fission, with the ensuing chain reaction in the body and in the environment.

All media are active metaphors in their power to translate experience into new forms.

All media of communication begin as links or bridges between people and things and end as substitutes for the things with which they had originally established new contact.

All the new media, including the press, are art forms which have the power of imposing, like poetry, their own assumptions.

An archetype is a retrieved awareness of consciousness,
a quoted extension, medium, technology or environment.
New archetype is old cliché writ large.

An insight is the sudden awareness of a complex process of
interaction—an insight is a contact with the life of forms.

Any new technology, any extension or amplification of human faculties when given material embodiment, tends to create a new environment. This is as true of clothing as of speech, or script, or wheel. This process is more easily observed in our own time when several new environments have been created.

Art, like games, is a translation of experience. What we have already felt or seen in one situation we are suddenly given in a new kind of material.

As a piece of technology, the clock is a machine that produces uniform seconds, minutes, and hours on an assembly-line pattern. Processed in this uniform way, time is separated from the rhythms of human experience. The mechanical clock, in short, helps to create the image of a numerically quantified and mechanically powered universe.

As the new media unfold their powers, the entertainment industries swallow more and more of the old business culture.

As with the new globe-girdling environments, the world itself becomes garbage, a museum of archetypes, simultaneously all the people on the planet are thrust into roles of creativity.

At electric speeds, all that had been gigantic under industrial hardware conditions returns to human scale.

At instant speeds all reaction and adjustment are inevitable, but too late to be relevant.

At instant speeds, the world market, invoked by industrial activities, becomes a software service, yielding only software images and satisfactions.

At the same time as Monet and Seurat and Rouault were dimming the visual parameters of art to achieve maximal audience participation, the Symbolists were demonstrating the superiority of suggestion over statement in poetry.

Blast those art galleries and museums which classify and imprison human spirit.

Blast the Communist Manifesto. Rear-view mirror of a

Féte accompli,

Fate accompli,

Faît accompli …

By coordinating and accelerating human meetings and goings-on, clocks increase the sheer quantity of human exchange.

Clothing and housing, as extensions of skin and heat-control mechanisms, are media of communication, first of all, in the sense that they shape and rearrange the patterns of human association and community.

Conformity is an intense form of individualism.

The more intense the competition, the more individuals you have, the more people resemble each other.

Cracking the code of our own popular culture is much harder than the problem of the Rosetta Stone image.

Credit agencies have enormously depreciated our individuality with their bugging industry, in the process of propping up our egos.

Culture is not civilization. Every day we get more cultured and less civilized.

Editorial policy is of minute effect compared to the art form of the page itself.

Even in the old sense of a business, moving information far outranks "heavy" industry.

Every culture that ever existed has a sensory bias or preference which is its hidden environment or surround.

Every technical innovation creates a new environment that alters the inner image or identity of entire cultures.

Every technology contrived and outered by man has the power to numb human awareness during the period of its first interiorization.

Every time we create a new service environment we put a huge new world around ourselves, which transforms our lives and purpose.

For the painter, it is the unswept street, the abandoned breakfast table, that reveals the order.

Genetically, womb-wise touch is prior and may be the sense from which others become specialized variants.

Good taste is the first refuge of the non-creative. It is the last-ditch stand of the artist.

Ground cannot be dealt with conceptually or abstractly, it is ceaselessly changing, dynamic, discontinuous, and heterogenous, a mosaic of intervals and contours.

Iconic space is discontinuous, and nonuniform, and nonconnected. It is a space in which the objects create their own environment.

In a newspaper, most trivial matters are given considerable additional intensity by being translated into prose at all. That is why no account of anything can be truthful in a newspaper.

In the age of the photograph, language takes on a graphic or iconic character, whose "meaning" belongs very little to the semantic universe, and not at all to the republic of letters.

In the all-at-once-ness of electric technology we humbly encounter the man from the backward country as avant garde.

In the case of all technologies and innovations, the ground must be prepared in advance of the arrival of the cause.

In your own experience, you are always the figure, as long as you are conscious. The ground is always the setting in which you exist and act.

Instead of having a gestalt, a figure and ground, writing leaves you only with figure.

Interface refers to the interaction of substances in a kind of mutual irritation. In art and poetry this is precisely the technique of symbolism.

It is puzzling to know how Marx managed to ignore the media of communication, as the major factor in the process of social change. For the means of production, especially since Gutenberg, are so many footnotes, or appendages, of the printing press itself.

It is impossible to understand social and cultural changes without a knowledge of the workings of media.

It is the character of the instantaneous that makes mere categories and classifications obsolete and demands that we do a structural analysis of the problems in any field.

It is the framework that changes with new technology, and not just the picture within the frame.

It is very hard to get a man in the print belt of culture to recognize that the form of print is itself cultural and deeply biased. The fish knows nothing of water.

Just what science or philosophy was at this time will be manifested by what each does to the other.

Language is metaphor in the sense that ît not only ſtores but translates experience from one mode into another.

Light is information without "content," much as the missile is a vehicle without the additions of wheel or highway. As the missile is a self-contained transportation system that consumes not only its fuel but its engine, so light is a self-contained communication system in which the medium is the message.

Like our vernacular tongues, all games are media of interpersonal communication, and they could have neither existence nor meaning except as extensions of our immediate inner lives.

Logos is the formal cause of the kosmos and all things, responsible for their nature and configuration.

Mass Media Hypotheses (1960)

I. Mass culture is electric — the telegraph and after.

2. Popular culture was and is derivative from print and from the mechanisms of production and marketing based on the assembly-lines of movable type.

3. Popular and elite culture alike are consumer-oriented — based on a dichotomy of production and consumption which no longer obtains under electric conditions.

4. Mass media are producer-oriented like tribal societies. Empathic, "with it," they include the consumer or public in themselves as process, and do not address the public.

5. Mass media since the telegraph do not speak *to* a public but *through* the public. The TV Image merely makes this fact more obvious.

6. The emphatic dimension which constitutes a mass medium and a mass culture is simultaneity. All-at-onceness is resonating inclusiveness of all components and all levels, as in spoken but not written language.

7. In the West, written, print, and mechanical cultures are based on the one-thing-at-a-time technology of the phonetic alphabet. This technology and its heritage are at odds with electricity.

8. Media technology is an abstraction and extension of one or another of our senses. Today our total sensorium is externalized.

9. In the West the business of art has long been the assimilation of technological change in order to correct the distortion of our senses created by new technology. Under electric conditions the artist becomes the only available social navigator. His alienation from society is ended.

10. The "content" of any medium is another medium.

11. The understanding of media as art forms is achieved by translation of one medium into another.

Media are artificial extensions of sensory existence, each an externalized species of the inner genus sensation.

Men on frontiers, whether of time or space, abandon their previous identities. Neighborhoods give identity. Frontiers snatch it away.

Merely to introduce any portion of the environment into an enclosed space, or a non-environment, is to become conscious of it, and, in effect, is to archetypalize it.

Money as such has become a pseudo-event, information only.

Money is the poor man's credit card.

News is a massive, collective preference. News is a fragment of what people choose to allow to be staged out of innumerable actions and motivations, that are actually current and available. News creates and massages special publics.

News is an artefact where media are concerned. Any kind of good or bad news can be turned on or off at will for varying periods.

Nobody yet knows the language inherent in the new technological culture; we are all deaf-blind mutes in terms of the new situation. Our most impressive words and thoughts betray us by referring to the previously existent, not to the present.

Obsolescence means that a service has become so pervasive that it permeates every area of a culture like the vernacular itself. Obsolescence, in short, ensures total acceptance and even wider use.

Official culture still strives to force the new media to do the work of the old media. But the horseless carriage did not do the work of the horse; it abolished the horse and did what the horse could never do.

Once a new technology comes into a social milieu it cannot cease to permeate that milieu until every institution is saturated.

One medium of expression modifies another, as one language is changed by contact with another.

One sure way to perceive the structure of any situation easily is to reverse its figure/ground relationship.

Only by standing aside from any phenomenon and taking an overview can you discover its operative principles and lines of force. Ordinary men, however, when confronted by new environments, resort to the rear-view mirror.

Our consciousness of the hidden environmental processes is heightened by the speed of the arrival of new environments and dimensions.

Our typical response to a disrupting new technology is to recreate the old environment instead of heeding the new opportunities of the new environment. Failure to notice the new opportunities is also failure to understand the new powers.

Perhaps the most significant of the gifts of typography to man is that of detachment and non-involvement—the power to act without reacting.

1. Print had created the Public, that is, a large group of separate individuals accessible through a common language and a common language territory. Electric circuitry substitutes The Mass for the Public.

2. In contrast to the Public, The Mass consists of people quite deeply involved in one another by virtue of enormous speedup of information services.

3. Electric speeds of information in effect pull out the times and spaces between people, as can be noted in the makeup of the daily paper.

4. Many people talk as if The Mass represented merely a much larger group of people than the old Public. In point of fact, mass has less to do with size than speed. That is why the most trivial events, when circulated at electric speeds, can acquire enormous potential and influence.

5. To think of the mass audience as merely larger and more vulgar than the old reading public is a good example of the rear-view mirror vision of the world.

Print, in turning the vernaculars into mass media, or closed systems, created the uniform, centralizing forces of modern nationalism.

Rapid changes of identity, happening suddenly and in very brief intervals of time, have proved more deadly and destructive of human values than wars fought with hardware weapons.

Sculpture is auditory, not visual because it makes its own configuration and resonates.

Since all media are extensions of ourselves, or translations of some part of us into various materials, any study of one medium helps us to understand all the others.

Slang is verbal violence on new psychic frontiers. It is a quest for identity.

Smoothness and repetitive order, the attributes of teeth, enter into the very nature of the power structure.

Symbolism consists in pulling out connections.

Take the date line off a newspaper and it becomes an exotic and fascinating surrealist poem.

Television and radio are immense extensions of ourselves, which enable us to participate in one another's lives, much as a language does. But the modes of participation are already built into the technology; these new languages have their own grammars.

Television will not be understood until it too has become obsolete. At the moment of obsolescence, anything becomes an art form. And then it is possible to do something very good with it.

The abstract side of the brain, the left hemisphere, is figure without ground. It is logical and lineal and connected. It has classification, places to put things. It has syntax, grammar, order, which is all figure without ground.

The amateur can afford to lose. The expert is the man who stays put.



The amateur can afford to lose. The expert is the man who stays put.

The art of remaking the world eternally new is achieved by careful and delicate dislocation of ordinary perceptions.

The artist has merely to reveal, not to forge, the signatures of existence. But he can only put these in order by discovering the orchestral analogies in things themselves.

The book is a more passive form than radio — it is a more completely packaged form of information.

The car has become the carapace, the protective and aggressive shell, of urban and suburban man.

The classic curse of Midas, his power of translating all he touched into gold, is in some degree the character of any medium, including language. This myth draws attention to a magic aspect of all extensions of human sense and body; that is, to all technology whatever.

The content of any work, philosophical or physical, is the efficient cause in the situation. The formal cause concerns the effects proceeding from the total structure of the situation, which includes the public and the users. It is the formal cause which constitutes the environmental violence, the side effects of the media.

The cool TV medium cannot abide the typical because it leaves the viewer frustrated of his job of "closure" or completion of image. President Kennedy did not look like a rich man or like a politician. He could have been anything from a grocer or a professor to a football coach. He was not too precise or too ready of speech in such a way as to spoil his pleasantly tweedy blur of countenance and outline. He went from palace to log cabin, from wealth to the White House, in a pattern of TV reversal and upset.

The corporate image is the most involving of effects for it is really made up of public attitudes.

The English language is an enormous medium that is very much more potent and effective than anything that is ever said in English.

The environment always manages somehow to be invisible. Only the content, the previous environment, is noticeable. The BOMB itself became content, having had a short reign as environment.

The environment is always "invisible" and its content is always the old technology.

The future of the city may be very much like a world's fair:
a place to show off technology, not a place of work or residence
whatever.

The guy who is going to use a superhighway thinks he is the
same man who used the dirt road it replaced ... He doesn't
notice that the highway has changed his relation to his family
and his fellows.

The hotting-up of the medium of writing to repeatable print intensity led to nationalism and the religious wars of the sixteenth century.

The instant character of electric information movement does not enlarge, but involves, the family of man in the cohesive state of village living.

I. The Laws of the Media are based on the discovery that all our artifacts, all our sensory and motor accessories, are in fact, words. All of these things are outerings and utterings of man.

2. In my own Laws of the Media I have tried to show that all technology whatever, whether verbal or non-verbal, whether software or hardware, is linguistic in structure.

The loss of individual and personal meaning via the electronic media ensures a corresponding and reciprocal violence from those so deprived of their identities, for violence, whether spiritual or physical, is a quest for identity and the meaningful.

The mass media are extensions of the mechanisms of human perception; they are the imitators of the modes of human apprehension and judgment.

The media tycoons have a huge stake in old media by which they monopolize the new media.

THE MEDIUM IS THE MESSAGE.

(A) All media (all technologies) amplify human faculties or attributes.

(B) All media obsolesce or displace some function or functions by extending the environment of services quantitatively.

(C) All media retrieve older forms of service and communication.

(D) All media pushed to their limits of capacity flip into some opposite form.

The mere format of the page of newsprint was more revolutionary in its intellectual and emotional consequences than anything that could be said about any part of the globe.

The metropolis is obsolete. Ask the Army.

The mind of the artist is always the point of maximal sensitivity and resourcefulness in expressing altered realities in the common culture.

The moment of translation is the moment of creativity (and discovery).

The moment one detaches himself from any particular medium of expression and considers the nature and ends of communication as such, he begins to develop that simultaneous sense of cultural unity and of the orchestration of the media, written, oral, sculptural, musical and pictorial.

The Negro response to the auditory and acoustic space created by radio was to give a new art form to every country in the world. Jazz is slowed down speech and speeded up motion. Syncopation or ragtime is the discontinuous space that characterizes sound as much as it does electric current. Only visual space is a continuum . . . The real Negro integration took place in the 1920's when the whole world was assimilated to Negro culture.

The phonetic alphabet forced the magic world of the ear to yield to the neutral world of the eye.

The photograph has reversed the purpose of travel, which until now had been to encounter the strange and unfamiliar.

The print-made split between head and heart is the trauma that affects Europe from Machiavelli to the present.

The right word is not the one that names the thing but the word that gives the effect of the thing.

The power of radio to retribalize mankind, its almost instant reversal of individualism into collectivism, Fascist or Marxist, has gone unnoticed.

The present is very difficult to see. It takes enormous energy, and most people don't have enough energy to see anything, let alone the present. That's why they talk about the future.

The road is our major architectural form.

The time is not far away when the elite and culture heroes of the society will be granted the special privilege of having their data-bank records erased, when they will be accorded the dignity of individuals by insulating them against the privacy-invading knowledge industries.

The trouble with a cheap, specialized education is that you never stop paying for it.

[The TV image] makes the viewer the screen and drives him inward. Its broken lines and points communicate a powerful tactual image, with sculptural contours rather than visual definition. This image favors a habit of experience in depth in all our sensibilities. Depth in motivation study, depth in reading and in word awareness, depth in textures in our homes, our cars, our food. And above all, depth of participation in all those processes from which we had formerly accepted the product in passivity.

The TV screen just pours that energy into you which paralyzes the eye; you are not looking at it, it is looking at you.

To behold, use or perceive any extension of ourselves in technological form is necessarily to embrace it. To listen to radio or to read the printed page is to accept these extensions of ourselves into our personal system and to undergo the "closure" or displacement of perception that follows automatically. It is this continuous embrace of our own technology in daily use that puts us in the Narcissus role of subliminal awareness and numbness in relation to these images of ourselves.

To most men, experience is like the stern lights of a ship, which illumine only the track it has passed.

To say that any technology or extension of man creates a new environment is a much better way of saying that the medium is the message.

To say the GNP has become an obsolete tool, is another way of saying that it has just begun to penetrate the entire system. It has become the national icon.

To the person of book culture, habituated to think of the book as a neutral environment serving his independent mind, it is heresy to say that the impact of these forms is quite separate from anything they happen to be used to say or express.

To use a brand of car, drink, smoke or food that is nationally advertised gives a man the feeling that he belongs to something bigger than himself.

Translation need not be verbal, any more than coding need be. Many of the most potent aspects, even of verbal media, are non-verbal. But translation releases great power, in media and cultures, by revealing the underlying codes, and by causing dramatic inter-penetration and metamorphosis among these.

Trying to make TV like a photograph or movie is utter nonsense. The whole dynamic of TV is to go inside the viewer.

Typography tended to alter language from a means of perception and exploration to a portable commodity.

Visually biased, or left hemisphere people, accustomed to the abstract study of figures minus their ground, are commonly upset by any sudden intrusion of the forgotten or hidden or subliminal ground.

Western literate man is easily inclined to make moral protests, but is seemingly incapable of recognizing the formal or "acoustic" structure of situations which are disturbing and destroying him.

Western man is torn between the claims of visual and auditory cultures or structure.

When a community develops some extension of itself, it tends to allow all other functions to be altered to accommodate that form.

When I say that "the medium is the message" I don't question the "content", but point out that every medium is a hidden service environment.

When reading or when in the motor car or watching TV or listening to the radio we are pretty unaware that we're merely obsessed, fascinated with a little bit of ourselves, stuck out there, in another material.

While bemoaning the decline of literacy and the obsolescence of the book, the literati have typically ignored the imminence of the decline of speech itself. The individual word, as a store of information and feeling, is already yielding to macroscopic gesticulation.

Why do newsmen covet the air of cynical omniscience and detachment, yet act like crusaders? The rustic scene accentuates the positively phoney?

With the computer we all move out of the age of number and statistics into the age of the simultaneous awareness of structures.

With telegraph, with the electric and instantaneous, we encounter the same tribal inclusiveness, the same auditory and oral totality of field, that is language.

With the electric speed of information movement a dramatic change occurs: what had formerly been audience, becomes actor.

As our society becomes more conscious of its unity and interdependence, and as tradition and novelty enter into fruitful marriage, we shall discover how to penetrate and to import various kinds of knowledge in ever speedier and simpler ways. The awareness today of the close parallel between the modes of sensuous apprehension and the modes of the creative process have begun to abridge many tedious processes. Learning and creating are becoming very near to each other. Just when it seemed that we had created an intolerable amount of knowledge for future generations to preserve and diffuse, we have discovered how to apprehend it swiftly from within. Harmony and ease among the many kinds of knowledge, among the arts and sciences, between living and learning and between learning and creating — these are only a few of the kinds of perception and activity made available today through a wedding of the traditional arts and the new media.

(Fragment 143-14, NATIONAL ARCHIVES, CANADA)

ALBUM

for Harley

THROUGH THE VANISHING POINT

Unoccupied space is tactile
and kinesthetic. It is only
by these senses that it is
felt. It is not visual space.

tabula _rasa_: tactile, empty

The Renaissance created the void
into which to put objects.

Constable: "Don't paint the object.
Paint the space around
it."

a curved space
()
space is curved

Instead of allowing things to
make space, the 16th century
made space in which to put
things.

From Giotto to Cézanne the
viewer is held mainly in the
tactile mode of experience,
being offered the pictorial.

If SI is pictorial (HD)

then the SC is tactile (HD)
and even SI is tactile (LD)

OBJECTS ARE RATIOS OF THE SENSES

What is the peculiar psychic bias
of a world in which the (pictorial)
visual sense is in HD at the expense
of the other senses?

SI and SC (impact & completion)
bear a relationship as
figure relates to background.

The SC curve is the reverse
of the SI curve.

LEFT AND OPPOSITE PAGE:

"For Harley". Notes for a
book by Marshall McLuhan
and Harley Parker, _Through
the Vanishing Point: Space in
Poetry and Painting_, published
by Harper & Row, New
York, 1968. (HD) High
Definition, (LD) (Low
Definition), (SI) Sensory
Impact, (SC), Sensory
Completion

(NATIONAL ARCHIVES, CANADA)

Any LD object evokes maximal
response in its own mode.

In Caravaggio, the subjective completion
of "miraculous" is in high definition.

Perspective is basically completion,
not impact.

When perspective was new, the viewer
was biased toward a tactile SI, and
so was shocked into a recognition
of the pictorial (i.e. abstraction).

> LINE in drawing and and general
> composition takes on a new meaning
> in Gutenberg era, so that we cannot
> help but regard the lines of pre-
> pictorial space differently.

> > e.g. hieroglyph is thing,
> > does not refer to thing

> (Mac said "OmahA: beginning of my
> Great Chiasmus.")

In Baroque painting:

> components in HD
> composition in LD (pictorial)

SC = non-sensory

SI = sensory CONTENT: medium within
 medium

> Refer to the principle of translation.
> Words referring to something else.

> The moment of translation is the
> moment of creativity (and discovery).

"Classical is better than nature
because eclectic."

SI-SC A propos of Berenson tactile values
 for retinal impressions.
 Balanced diet:
> > the whole problem of rela ting
> > the arts and technology is to
> > effect a balanced diet for
> > each of the senses.

The people of The Book

In one way North America in the seventeenth century was like China or Indonesia in the twentieth. The first technology we got was the latest European technology. Today the East gets our latest technology minus the intermediate technology. We got the printing press from Europe, They get radio and electronics from us.

The printing press was not only the latest European technology; its product, the book, was the only form of culture that could be easily and cheaply exported from Europe. In Europe the book had a revolutionary impact on music, poetry, painting, architecture philosophy and education. In America it was a substitute for all those things. All media of communication begin as links or bridges between people and things and end as substitutes for the things with which they had originally established new contact.

LEFT AND OPPOSITE PAGE:

The People of the Book, 1959
"Writings on the Individual and
Nationalism". 17 handscript page

(NATIONAL ARCHIVES, CANADA)

Substitution of this kind is inherent in the very process by which the original function is accomplished with ever increased efficiency. In the ancient world the road, established to link cities, quickly ended the city-state. Today the highway established by the motor-car to link town and country is not only a wall between man and nature it is a substitute for nature. The newspaper began as a link between men and society at large, but with the telegraph and pictorial journalism its inclusiveness and speed made of it a world in itself rather than a means of critical appraisal of events.

~~Radio~~ Movies, radio and TV almost began at the newspaper terminal.) from the first they acted as substitutes for, rather than links with reality. As our technology becomes speedier

Today our acoustic technology is beginning to restore the ancient union of words and music, but especially the tape recorder has brought back the voice of the bard.

Candidates are now aware that all policies and objectives are obsolete. Perhaps there is some comfort to be derived from the fact that NASA scientists are in the same dilemma.

While pursuing the Newtonian goals of outer space, they are quite aware that the inner dimensions of the atom are very much greater and more relevant to our century.

Marshall McLuhan in front of his home in Wychwood Park, Toronto. (Photograph: Robert Fleming)

The artist, because he uses all his faculties, is always at leisure, and always merging.

for Corinne McLuhan

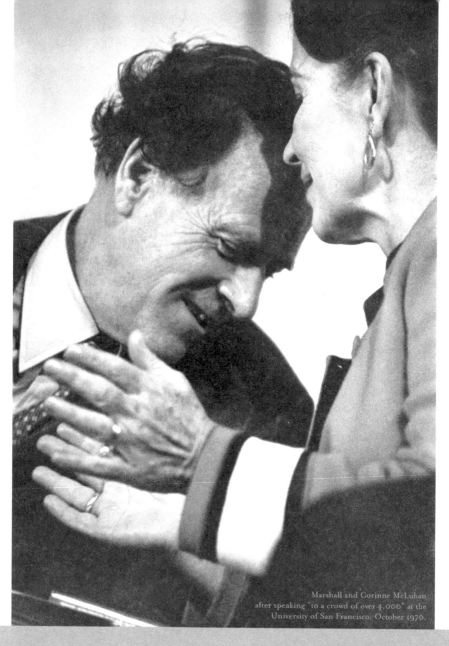

Marshall and Corinne McLuhan
after speaking "to a crowd of over 4,000" at the
University of San Francisco, October 1970.

Adapted from a manuscript submitted by
Eric McLuhan and William Kuhns

Design, Art Direction, Photography:
David Carson

Concept and Direction, Probes Project
Mo Cohen

Project Consultants
Dominique Carré, Marianne Véron, Teri McLuhan,
Michael McLuhan, David Lopes, Rick Markell

Pre-Press Image Editing
 Staple Design
 Julie von der Ropp
 Cezanne Studio

Research
 William Kuhns
 Eric McLuhan
 Mo Cohen

All artwork in pages 4-400 is by David Carson
except
pages 167, 168-169, by Laura Berman;
pages 158-161, plus special effects in Overture by Deanne Cheuk;
pages 128-129, 310-311, 332-333 and 380-381 by Michael Lotenero;
pages 172-173, 256-257, 259, 261, 316-317, 339 and 350-351 by Jason Rohlf.

Images from Tom Wolfe—Video McLuhan, written and narrated by Tom Wolfe—
directed by Stephanie McLuhan appear on pages 66-67, 306-307, and 394-395.

The following people have lent their kind support or advice to the Marshall
McLuhan Probes Project:

Jerome Agel	Rainer Hoeltschl	Matie Molinaro
Martin Baltes	Rico Komanoya	Sari Ruda
Antoine Dulaure	Bill Marshall	Rudolf van Wezel
Theresa Gordon	John Martin	Donna Wiemann

Eric McLuhan

worked closely with Marshall McLuhan for the last years of his life and assisted him with the research for and writing of articles and books. He co-authored, with Marshall McLuhan, *The City as Classroom* (1977) and *Laws of Media* (1988). He wrote *The Role of Thunder in Finnegans Wake* (1997), and *Electric Language: Understanding the Present* (1998), and has edited numerous other books and journals.

William Kuhns

is widely known for his work in the theory and implications of media and technology. His 17 books include *The Post Industrial Prophets, Environmental Man,* and *The Motion Picture Book.* He has been awarded a Guggenheim fellowship for his work in media theory.

DAVID CARSON

is widely considered to be the most influential graphic designer working today. Newsweek Magazine said Carson "changed the public face of graphic design". He lectures extensively, and his publications include *The End of Print: The Graphic Design of David Carson* (200,000 copies sold), *David Carson: 2nd Sight,* and *Fotografiks.* His new book is *Trek: David Carson, Recent Work*.

W. TERRENCE GORDON

studied at the University of Toronto, where he received his undergraduate and graduate degrees. He is the author of *Marshall McLuhan — Escape into Understanding* and *Marshall McLuhan for Beginners.* He edited the critical edition of McLuhan's seminal work, *Understanding Media: The Extensions of Man,* and is currently preparing McLuhan's doctoral thesis on the Trivium for publication. He has published 17 books and over 130 articles in the fields of linguistics, pedagogy, rhetoric, semiotics, and intellectual history.

GINGKO PRESS BOOKS BY MARSHALL McLUHAN

THE MEDIUM IS THE MASSAGE (2001)
 with Quentin Fiore and Jerome Agel

WAR AND PEACE IN THE GLOBAL VILLAGE (2001)
 with Quentin Fiore and Jerome Agel

THE MECHANICAL BRIDE – FOLKLORE OF INDUSTRIAL MAN (2002)
 with a new preface by Philip B. Meggs

UNDERSTANDING MEDIA – THE EXTENSIONS OF MAN (2003)
 Critical Edition edited by W. Terrence Gordon

THE BOOK OF PROBES (2003)
 with David Carson

MARSHALL McLUHAN UNBOUND: VOLUME ONE (2003)
 Edited by Eric McLuhan and W. Terrence Gordon

COUNTERBLAST (Facsimile Edition, 2003)
 with Harley Parker

2004

THROUGH THE VANISHING POINT — SPACE IN POETRY AND PAINTING
with Harley Parker

EXPERIENCE — UNDERSTANDING MEDIA
Various Artists

MARSHALL MCLUHAN UNBOUND
VOLUME TWO: THE GUTENBERG ERA

THE MEDIUM IS THE MASSAGE (Facsimile Edition)
with Quentin Fiore and Jerome Agel

THESIS: THE TRIVIUM
THOMAS NASHE AND THE LEARNING OF HIS TIME
Edited by W. Terrence Gordon

COUNTERBLAST (Revised Edition)

GINGKO PRESS BOOKS BY MARSHALL MCLUHAN IN PREPARATION

2005 + 2006

FOR MARSHALL MCLUHAN – CATALOGUE
 Edited by Dominque Carré

THE COMPLETE MECHANICAL BRIDE
Early Versions · Outtakes · Notes
with CD ROM

CULTURE IS OUR BUSINESS (Revised Edition)

THE LETTERS OF MARSHALL MCLUHAN
 Edited by Matie Molinaro and Corinne McLuhan

FROM CLICHÉ TO ARCHETYPE
 with Wilfred Watson

MARSHALL MCLUHAN UNBOUND
VOLUME THREE: ART, POETRY AND HOLLYWOOD

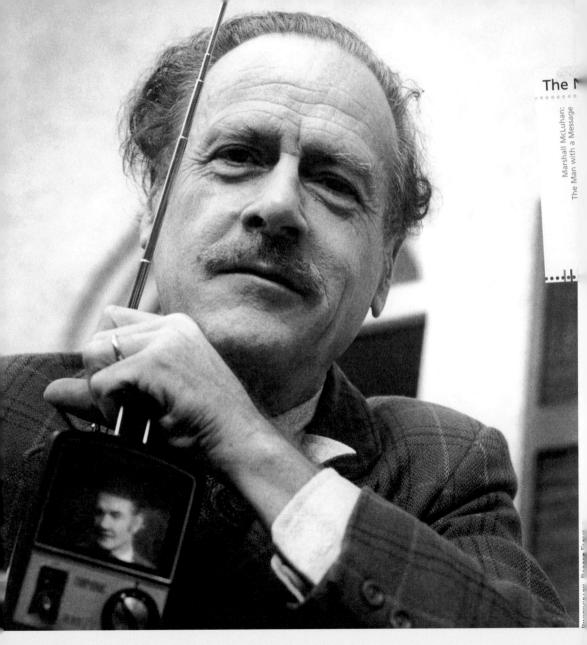

HERBERT MARSHALL McLUHAN (1911-1980)

One of the most controversial and original thinkers of our time, Marshall McLuhan is universally regarded as the father of communications and media studies. A charismatic figure, whose remarkable perception propelled him onto the international stage, McLuhan became the prophet of the new information age.

In his own time he drew both accolades and criticism for his intuitive vision and aphoristic style of writing and speaking. His steady stream of thought-provoking metaphors regarding culture and technology fascinated his listeners, especially those involved in the arts, politics, journalism, advertising, and the media. The information superhighway fulfilled his perceptive observation that the world would ultimately become a "global village."

Marshall McLuhan's work continues to influence a number of disciplines, in particular media studies, modern and contemporary art, and semiotics.

Marshall McLuhan received his M.A. in English literature from Trinity Hall, Cambridge. His doctoral thesis (Cambridge) is a critique of communication through the ages, recounting the rise and fall of poetics, rhetoric and dialectic through 2000 years of history. Styles of discourse, McLuhan wrote, ultimately influence not only knowledge but perception itself, and thereby determine the very nature of learning.

Published in the United States of America, November 2003
First edition

GINGKO PRESS, Inc.
5768 Paradise Drive, Suite J · Corte Madera, CA 94925
(415) 924-9615 · Fax (415) 924-9608
email: books@gingkopress.com
http://www.gingkopress.com

ISBN 1-58423-056-8

© 2003 Gingko Press, Inc.

Book design and cover design: David Carson

LIBRARY OF CONGRESS CATALOGING IN PUBLICATION DATA:
McLuhan, Marshall, 1911-
 Marshall McLuhan : book of probes / [compiled by] David Carson ;
compiled and edited by Eric McLuhan, William Kuhns, Mo Cohen.
 p. cm.
 ISBN 1-58423-056-8
 I. Mass media. I. Title: Book of probes. II. Carson, David, 1956-
III. McLuhan, Eric. IV. Kuhns, William. V. Cohen, Mo. VI. Title
 P91.25.M367 2003
 302.23--dc22
 2003020193

Printed by Graphicom in Verona, Italy